IMAGES
of America

LOUISVILLE

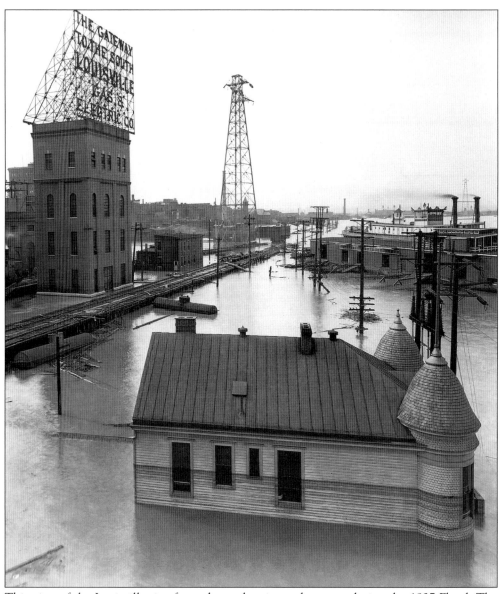

This view of the Louisville riverfront shows the city under water during the 1937 Flood. The sign on the Louisville Gas and Electric building had been erected by 1922, but there are no records of its origins, or who dubbed Louisville the "Gateway to the South."

IMAGES
of America
LOUISVILLE

James C. Anderson and Donna M. Neary

ARCADIA

Published by Arcadia Publishing,
an imprint of Tempus Publishing, Inc.
2 Cumberland Street
Charleston, SC 29401

Printed in Great Britain.

Library of Congress Catalog Card Number: 2001093050

For all general information contact Arcadia Publishing at:
Telephone 843-853-2070
Fax 843-853-0044
E-Mail sales@arcadiapublishing.com

For customer service and orders:
Toll-Free 1-888-313-2665

Visit us on the internet at http://www.arcadiapublishing.com

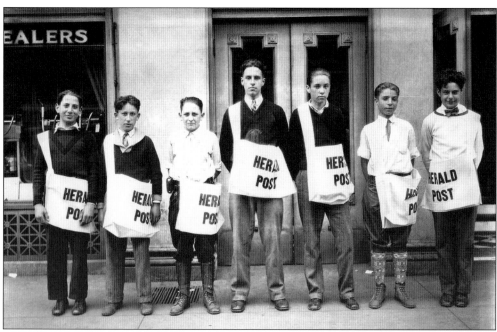

These boys are newspaper carriers for the *Herald-Post*. The paper was formed in 1925 with the merger of the *Louisville Herald* and the *Louisville Post*. The paper went bankrupt in 1936. Owner James Brown positioned the paper as the opposing view to editorial in the *Louisville Courier-Journal*.

CONTENTS

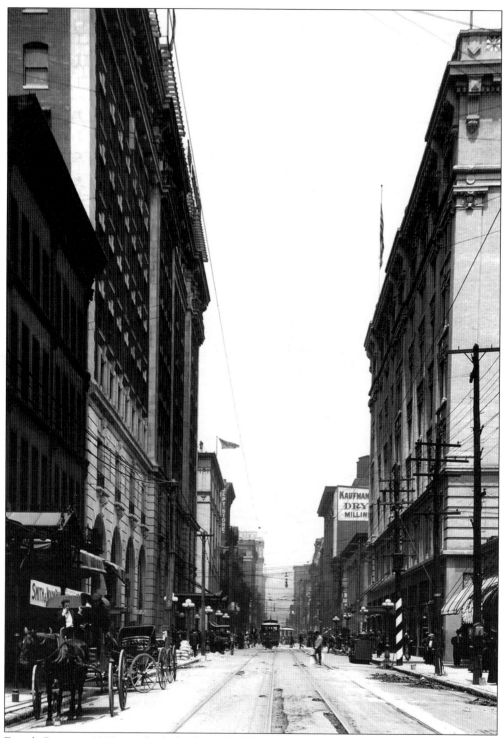

Fourth Street in 1905 was the hub of retail and entertainment activity for Louisville. Note the newly completed Seelbach Hotel, on the left, with a covered entrance. The completion of the Galleria in 1982 blocked this vista of Fourth Street.

INTRODUCTION

Louisville, Kentucky was founded in 1778 at the Falls of the Ohio by Gen. George Rogers Clark. Clark traveled from Fort Pitt with a small militia and 60 settlers during the American Revolution to hold off British and Indian advancement from the Illinois Country. The settlers built shelter and a fort and stayed to begin a town.

The strategic military position at the Falls of the Ohio served commercial enterprises as the western frontier developed. The Falls made it necessary for every traveler to stop at Louisville. Many early businessmen made their living transporting freight and travelers around the Falls. The earliest residences, hotels, stores, and warehouses clung to the shores of the Ohio River. As populations increased, the city fanned out from west to east, away from the river's edge.

The arrival of the steamboat in 1815 secured Louisville position as a key location for 19th-century commerce in the Ohio Valley and beyond. The completion of a canal at Portland in 1830 allowed fairly predictable river traffic for the first time since settlement. Not coincidentally, Louisville has been the largest city in Kentucky since 1830. Louisville's population rose dramatically in the 1840s and the city witnessed an explosion of manufacturing and distribution businesses. A city directory of 1844 lists a multitude of businesses including twelve foundries, two bagging factories, six cordage and rope factories, four flour mills, four lard oil factories, two potteries, three piano factories, eight brickyards, and three shipyards. The shipyards were responsible for the construction of 28 steamboats in 1843.

The first railroad carried freight and passengers from Louisville to Frankfort and Lexington, and was completed in 1851. The Louisville & Nashville Railroad was chartered in 1850 and made its first run to Nashville in 1859. The L&N quickly added branches to other Southern towns and provided employment to multitudes of Louisvillians in the rail yards, in the shops, and as crews for freight and passenger trains.

The Civil War from 1861 to 1865 almost halted completely the Southern trade from Louisville. Factories were individually affected depending on the goods being produced. Those making clothing, machinery, steamboat and other transportation supplies, and food provisions were kept in production to supply Federal demands for goods. Other factory buildings were called into service as barracks and hospitals for the Union Army.

Following the end of the Civil War, the railroad took predominance over the steamboat in shipping goods and services from Louisville, opening new markets for goods produced. The L&N Railroad put Louisville in contact with every city within a 300-mile radius. Manufacturing interests continued to grow, and Louisville leaders positioned the city to compete in the growing national and international economy. An industrial fair, called the Southern Exposition, covered 40 acres and remained open from 1883 to 1887 to showcase the industrial strength of this city.

Neighborhoods began forming on the fringes of the city to house emancipated blacks in the 1860s and 1870s, including Clifton Heights, Smoketown, Little Parkland, and California.

Berrytown and Griffytown had formed on the fringes of Anchorage in eastern Jefferson County. Subdivision of farm land and advances in transportation at the turn of the 19th century led to suburban developments dependent on rail lines and improved roads for automobiles. This suburbanization led to the extension of public utilities and services. Neighborhoods known as Audubon Park, Indian Hills, and Beechmont were formed.

A law signed by Mayor John Buschmeyer in 1914 mandated segregation in Louisville neighborhoods, forbidding whites and blacks from owning property on the same city block. This led to the evolution of parallel universes for blacks and whites living in the city. The Day Law passed by the state legislature in 1904 had already prevented blacks and whites from attending the same schools. Local industries employed both blacks and whites, who often worked together. Mayor Charles Rowland Peaslee Farnsley, who served from 1948 to 1953, began the work of desegregating the city and its institutions.

Louisville industries were called on during World War I to support the war effort. Camp Zachary Taylor hosted 28,000 Army recruits during the war. The enactment of Prohibition in 1920 had a profound impact on the community at large with numerous distilleries and breweries closed—approximately 6,000 people were let go from jobs. The Depression of the 1930s brought construction to a halt and many small businesses failed. The 1937 Flood devastated homes and businesses in Louisville and in the entire Ohio River Valley.

The end of Prohibition and the increasing need for goods for World War II infused new life into Louisville industries. Increased demand for housing and consumer goods followed the war. Several small cities were incorporated in the post-war era, and the community witnessed great changes in the rural landscape in the 1950s. The completion of the first expressway in 1958 led to widespread industrial and residential development on the outskirts of the city in unincorporated Jefferson County.

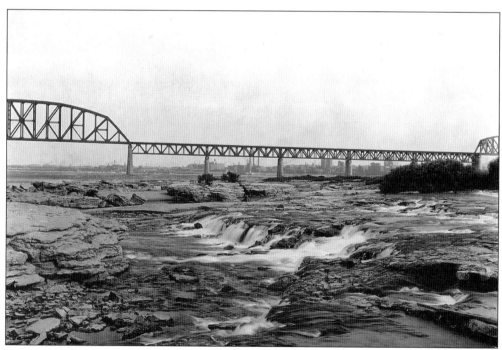

A view of the Falls of the Ohio, photographed in 1922, includes the railroad bridge and Louisville skyline in the distance. The area of the Falls is one of the largest exposed coral reefs in the world, dating from the Devonian Period, 350–400 million years ago.

One

LIFE IN LOUISVILLE

The people of Louisville have looked toward the Ohio River for transportation, commerce, news, and entertainment. The early city clung to the river and followed its natural shoreline from the beginning of the falls in the upper pool to its termination into the lower pool of the river.

From the earliest days of the city, Louisville residents developed housing, shops, and places of worship. During the 19th century, many shopkeepers lived above their stores in the center of the city. Later, neighborhoods such as Old Louisville, Parkland, and Crescent Hill were developed with single-family houses on subdivided lots.

The city-center continued to play a vital role in satisfying the needs of Louisville residents for goods and services into the 1950s. The widespread suburbanization of Jefferson County beginning in the 1960s changed the role of downtown Louisville from a round-the-clock center of activity to a nine-to-five weekday town. Efforts are being made to return the city-center to a prominent role for living, shopping, and entertainment.

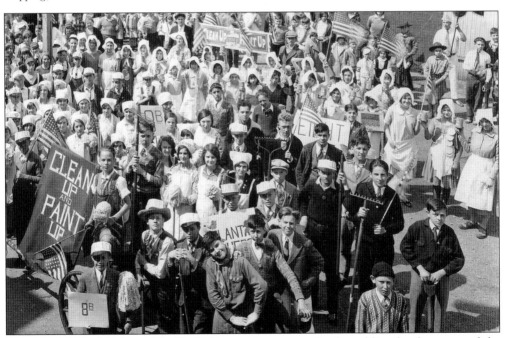

The 1929 "Clean Up, Paint Up, Fix Up" campaign was run by the public school system and the fire department. The program was aimed at removing combustible waste from the home and was continued into the 1950s.

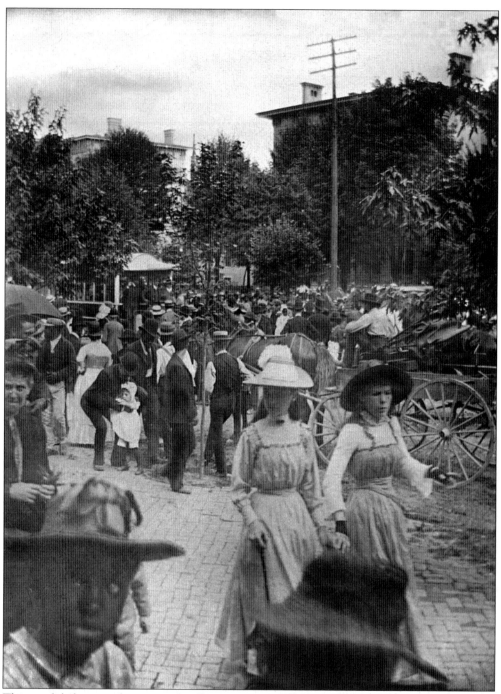

This candid photograph is unusual, offering a unique glimpse of Louisvillians going about their business on a summer day. The picture was snapped at the corner of Fourth and Broadway at the turn of the century. The buildings in the background were located on the southeast corner.

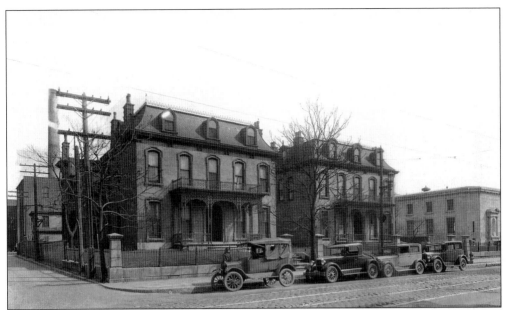

This 1929 view shows houses at 721 and 725 South Fourth Street built by bankers G.W. and W.F. Norton. The houses were decorated with Italianate details, including cast-iron porches. The Louisville Free Public Library's Main Branch at Fourth and York is on the far right of the photograph. By the time the photograph below was taken in the 1940s, the Norton houses had made way for a parking lot.

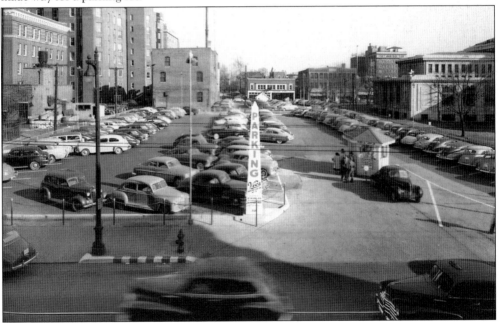

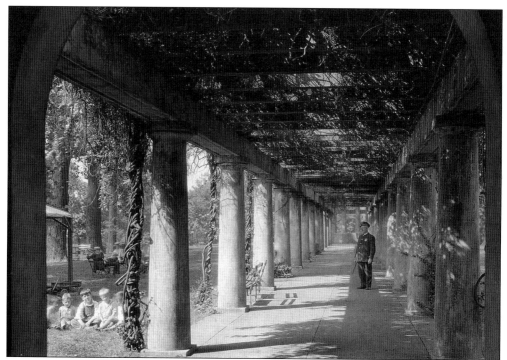

A police officer watches from the pergola in Central Park in 1926 as a group of small children play on the grass. The park, located in Old Louisville, was dedicated in 1902.

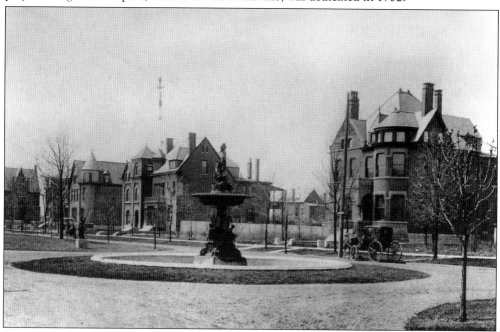

St. James Court, designed by William Slaughter and S.J. Hobbs, was modeled on fine residential developments in England. The original design included the central esplanade and cast-iron fountain, installed in 1890. The neighborhood was built on the site of the Southern Exposition, held from 1883 to 1887.

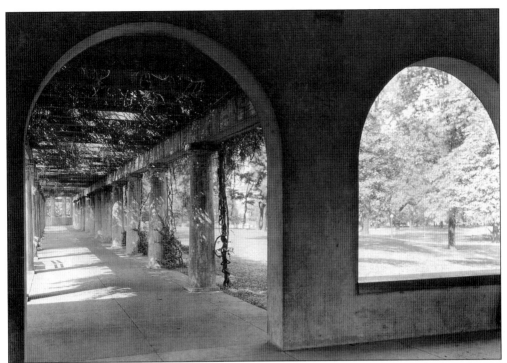

Central Park occupies 17 acres in the Old Louisville neighborhood. It is one of nearly 180 projects in Louisville and Jefferson County designed by landscape architect Frederick Law Olmsted and his successor firms.

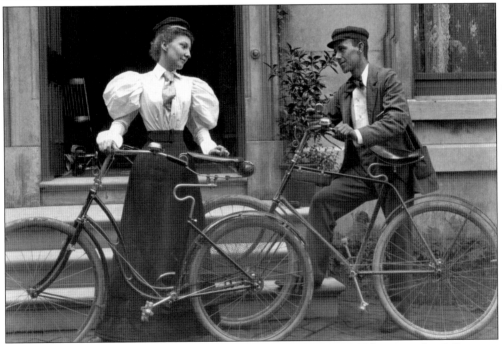

Mec Griswold and her cousin compare new bicycles at the Griswold home on Jacob Street as they prepare to participate in a ride staged by one of several cycling clubs.

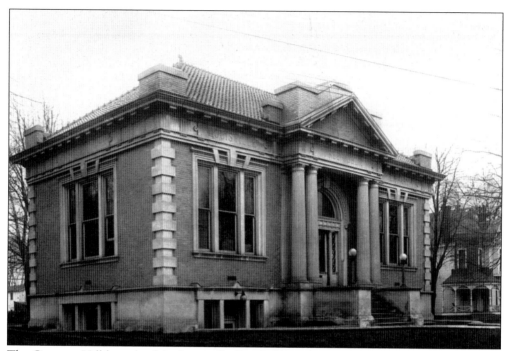

The Crescent Hill branch of the Louisville Free Public Library was built on Frankfort Avenue in 1908, and was funded by the Carnegie Foundation. The Crescent Hill neighborhood was incorporated in 1884 and annexed by Louisville between 1894 and 1922.

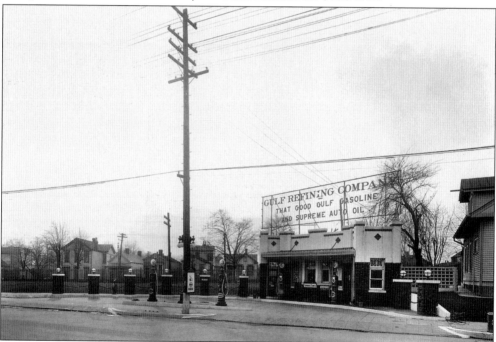

Frankfort Avenue was originally a toll road to the state capitol. This photo, taken in the Clifton neighborhood in 1927, features a gasoline station catering to the growing number of automobiles in the city.

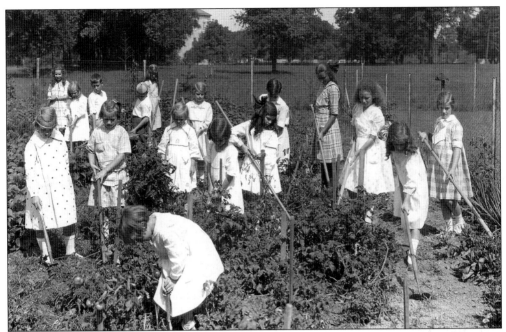

Children from Field Elementary on Sacred Heart Lane tend to their vegetable garden behind the school. The public school system promoted self-sufficiency in growing and canning foods during World War I.

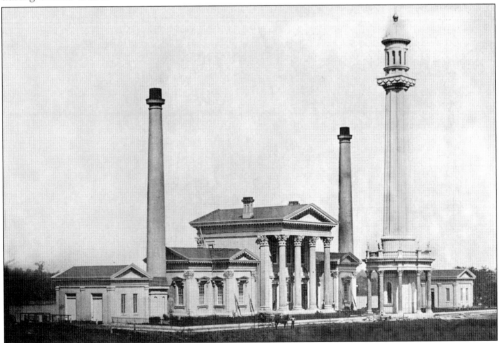

This photo shows the water tower and pumping station at River Road and Zorn Avenue under construction in 1859. When completed in 1860, the station provided clean water to the city for the first time. This ended cholera epidemics, which had gained Louisville the nickname "Graveyard of the West."

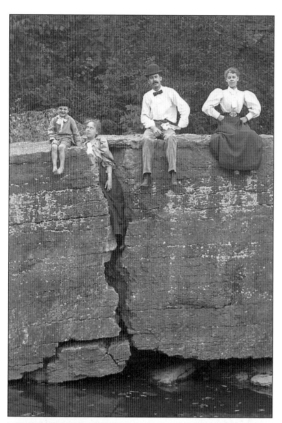

The Griswold family poses for the camera at Big Rock in Cherokee Park, c. 1896. Cherokee Park in eastern Louisville was one of three main parks designed by Frederick Law Olmsted.

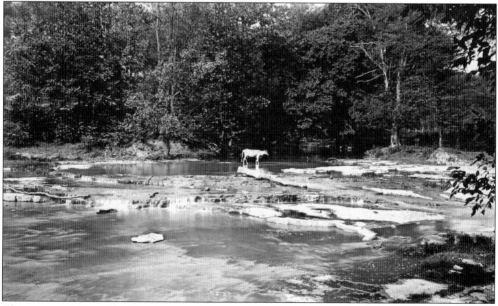

This scene of Beargrass Creek was taken near Big Rock before the area was incorporated as part of Cherokee Park. The park was designed by Frederick Law Olmsted; he also designed Central Park in New York City. Cherokee Park is considered one of Olmsted's most successful landscape designs.

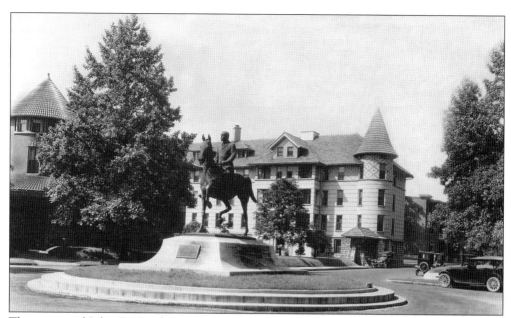

This statue of John B. Castleman is situated on a roundabout on Cherokee Road and was dedicated in 1913. Castleman served on the Board of Park Commissioners, and was instrumental in the development of Cherokee Park. An avid equestrian, he and mare "Emily" won the Grand Championship at the Chicago World's Fair in 1893.

The Cherokee Triangle neighborhood was begun in the 1880s, but was given a big impetus with the expansion of the streetcar line in the early 1900s. This house was built in the 1880s but updated and enlarged to include a stone facade. This 1936 photo is an advertisement for a masonry cleaning company.

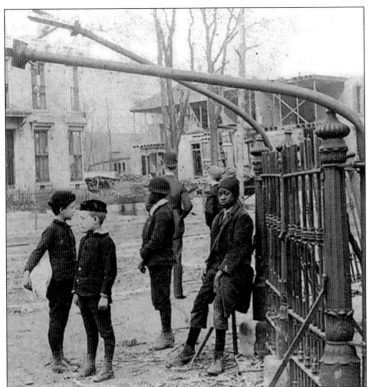

These boys are standing on Jefferson Street near the entrance to Baxter Square surveying the damage caused by the 1890 tornado. Note the bent iron rods and debris in the street in this view taken from a stereograph.

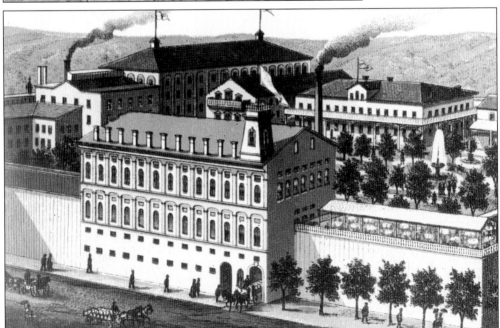

Phoenix Hill Park was built by the Phoenix Hill Brewery in 1865. The entertainment center, on Baxter Avenue between Payne and Rubel, featured concerts and housed a beer garden, indoor baseball diamond, and track for bicycle races. The brewery was closed in 1919 by the enactment of Prohibition.

This view of Bardstown Road, looking east from Highland Avenue, was taken in 1921. This area is part of a cluster of neighborhoods collectively known as the "Highlands."

Tyler Park was designed by the Olmsted firm in 1910 and gave a boost to the developing Tyler Park Neighborhood. Started in 1873, the neighborhood was slow to develop until the expansion of the streetcar line and the development of nearby Cherokee Park.

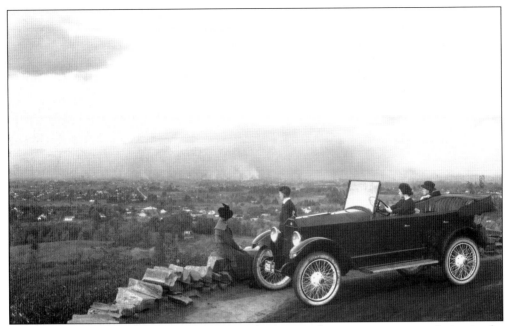

The Lookout at Iroquois Park has been a popular spot in the city since its completion in the 1890s. This photograph was an advertisement for the Dixie Flyer automobile manufactured by the Kentucky Wagon Manufacturing Company, one of Louisville's oldest businesses.

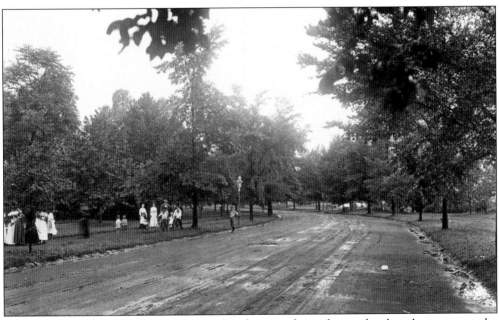

A central feature of the Olmsted-designed parks were the parkways developed to connect the three main parks to one another. Grand Boulevard, now Southern Parkway, led into Iroquois Park in Louisville's south end.

This photograph was taken around 1905 and depicts Hammers Park. The building was situated on the northwest corner of Taylor Boulevard at Southern Parkway, across the road from Iroquois Park.

This photograph records South Parkway at the intersection with Third Street in the Beechmont neighborhood. Taken in the 1920s, the view shows the development that occurred on the parkway over 20 years when compared with the photo on the opposite page.

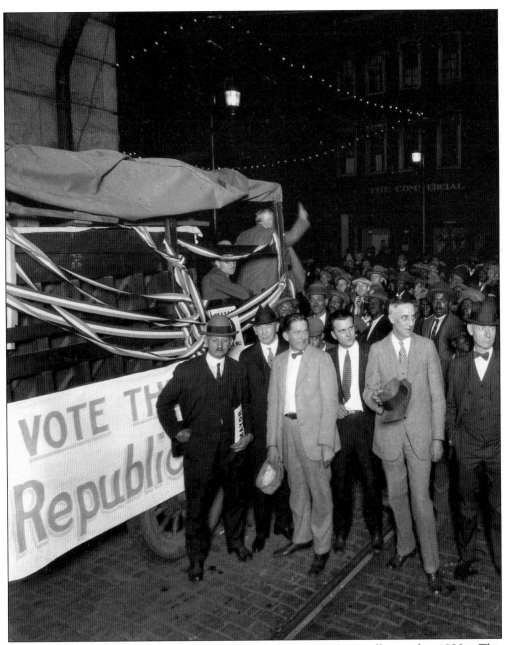

African Americans and women were politically active in Louisville in the 1920s. This campaign rally for the Republican Party candidate for mayor was held on October 9, 1925 at the Armory at the corner of Sixth and Walnut (Muhammad Ali Boulevard). The candidate, Arthur Will, speaking on the truck in the background, was elected. However, he was removed from office by the Kentucky Court of Appeals in 1927.

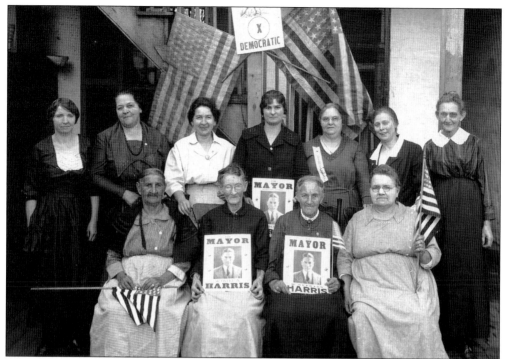

These women are campaigning for the Democratic Party's candidate for mayor. This was the first mayoral election in which women were eligible to vote, following the 1920 passage of the amendment giving women the right to vote. Republican Huston Quin won the race.

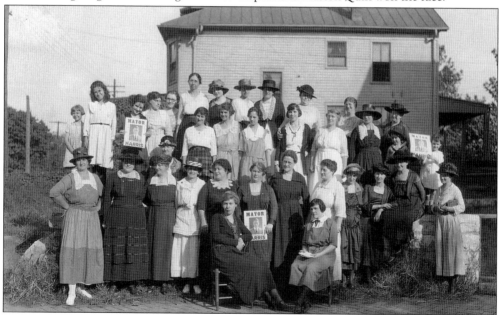

These women were working to promote the Democratic candidate for mayor in 1921. The League of Women Voters was founded in 1920 on the heels of the passage of the 19th Amendment and was an outgrowth of the Suffrage Movement. The Louisville League is one of the oldest in the country.

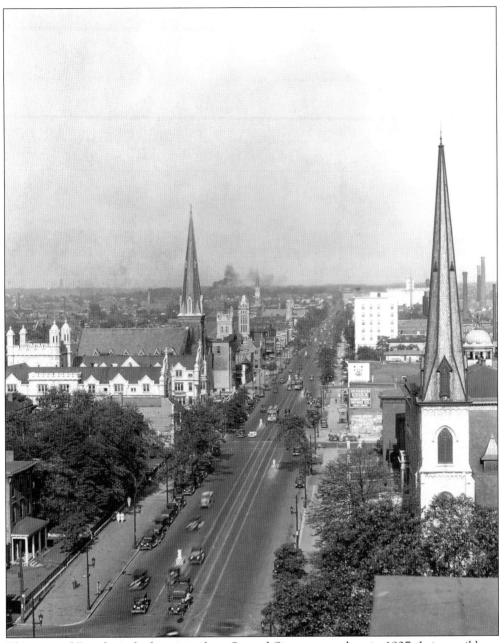

This view of Broadway, looking east from Second Street, was taken in 1927. It is possible to identify at least ten churches, including the steeple of Second Presbyterian in the foreground on the right and the dome of St. Xavier High School behind it. The Presbyterian Theological Seminary, in the foreground on the left, is now home to Jefferson Community College.

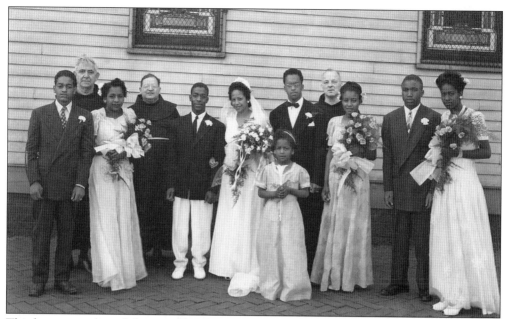

This happy couple and their wedding party were photographed by Royal Studio following the ceremony at St. Peter Claver Roman Catholic Church in the 1940s.

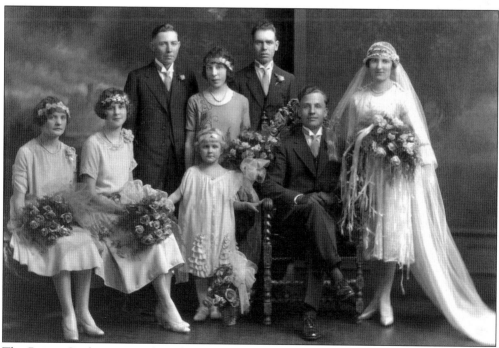

The Reiger Studio was run by John Reiger from 1901 to 1962. He used natural light in his studio at 810 Baxter Avenue and was considered the best portrait photographer in the city. This photo of a wedding party features the common pose with the groom seated and the bride standing, designed to best showcase her bridal attire without wrinkling the fabric.

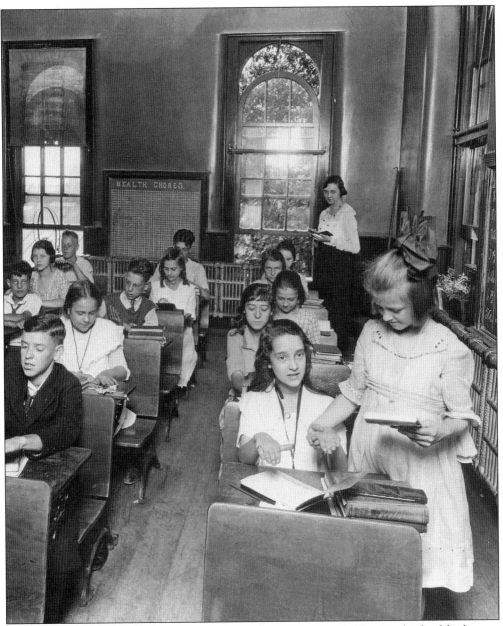

Cleanliness was stressed in the public schools in the 1920s. The children in this health class are conducting a fingernail inspection of their fellow students.

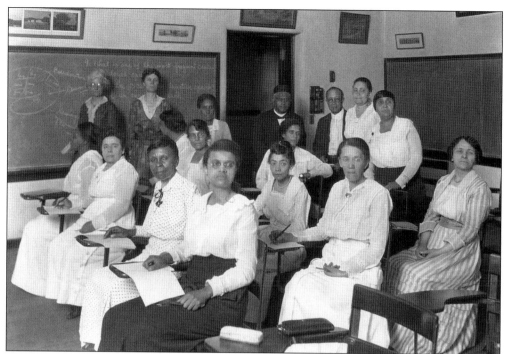

This group of women is taking part in an adult class at Central High School at Ninth and Magazine Streets. Taken in 1920, the photograph includes educator and poet Joseph Cotter with educator Albert Meyzeek standing in the doorway. The school was the first African-American high school in Louisville.

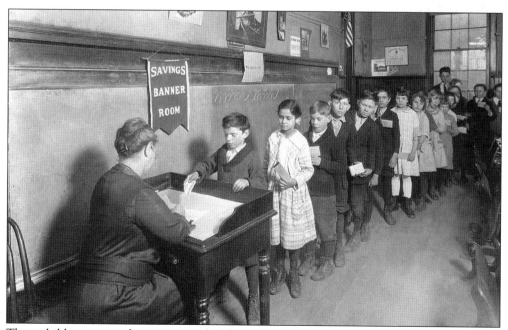

These children are purchasing savings bonds in the public schools in 1924. This practice carried over from the days of war bond sales during World War I.

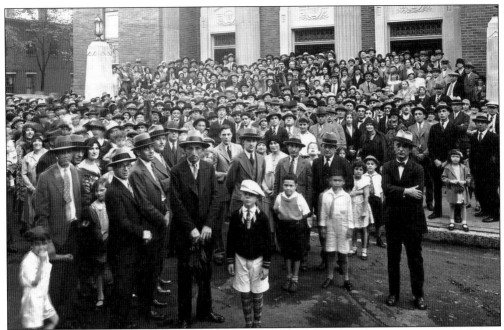

This photograph features the congregation of Keneseth Israel on Jacob Street at the southwest corner of Floyd. The synagogue was designed by Joseph & Joseph Architects and served as home to its members until suburban migration of the congregation led to new construction at 2531 Taylorsville Road in 1971.

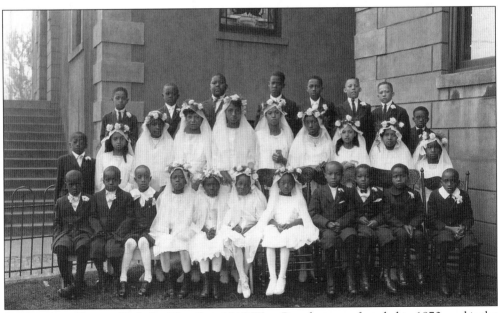

St. Augustine Roman Catholic Church at 1310 West Broadway was founded in 1870, and is the sixth oldest African-American Catholic church in the United States. These children are making their First Communion on May 1, 1921.

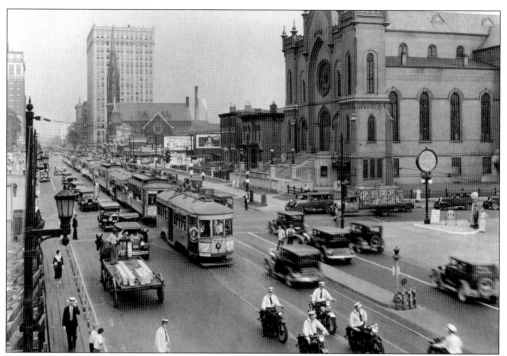

A parade of streetcars travels down Broadway toward the State Fairgrounds in west Louisville in 1932. The building on the right had been built as Adath Israel synagogue in 1868, but was being occupied by a Methodist congregation when this photo was taken.

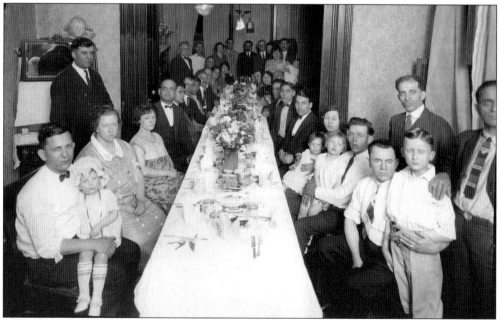

The family of Steve Avgerinos celebrates the baptism of the little girl sitting on her father's lap. The celebration was held in their East Market Street apartment. There was no established Greek Orthodox church in Louisville when this photo was taken in 1926. Greek families waited for a traveling priest to come to town to schedule weddings, baptisms, and other rites.

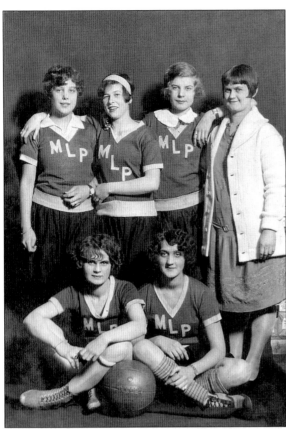

Mary's Little Peppers was a basketball team in a recreational league. Community programs and religious organizations across the city provided opportunities for children to play organized sports. It was often difficult for girls to find practice and playing facilities in the first half of the 20th century.

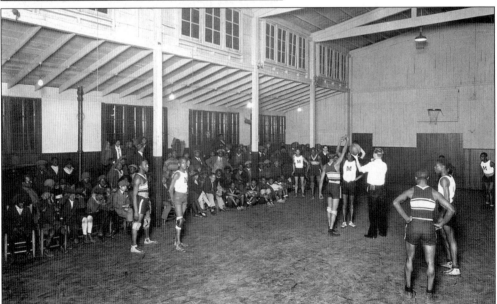

This basketball game is being played at the Presbyterian Community Center. The organization was staffed by Presbyterian Seminary students. A new center opened at the corner of Hancock and Finzer Streets.

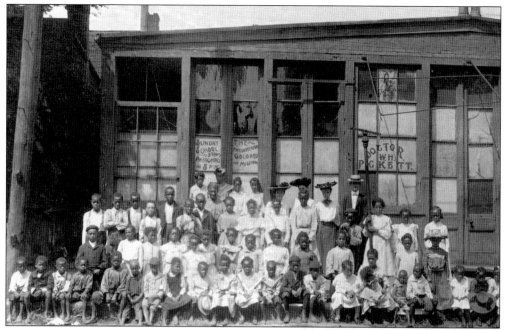

The Presbyterian Community Center opened this mission on Preston Street in 1898; a Sunday school group poses in front of the building in 1911. The center's director, Rev. John Little, opened the first playground for African-American children in the city.

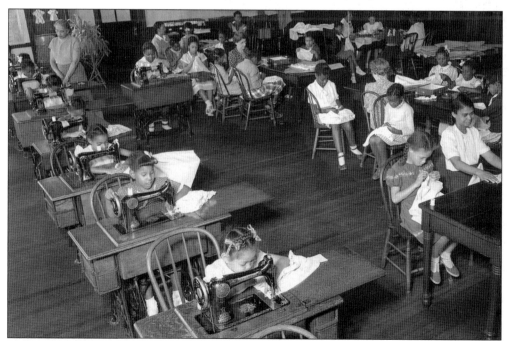

These little girls participate in a sewing class at the Presbyterian Community Center. The center sponsored innovative programs for African-American children, including industrial work classes and recreational opportunities. The center was incorporated in 1910 and received support from the Welfare League and the Community Chest.

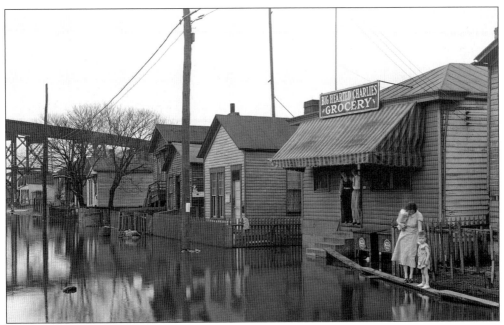

The 1937 Flood was devastating to neighborhoods across the city. Many people were forced out of their homes until waters receded. Unrelenting rainfall between January 9 and 23 caused the Ohio River to leave its banks and flood the entire river valley. Most of the Point, a neighborhood just east of the Big Four Bridge, was completely wiped out by the flood.

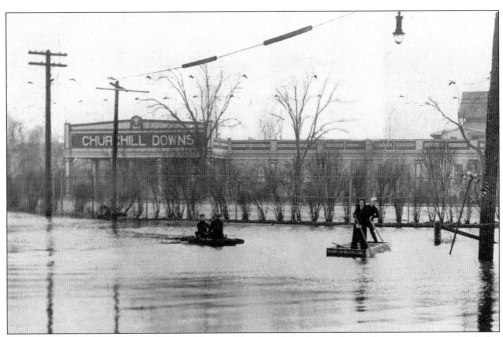

The residents of this south Louisville neighborhood had to rely on boats to get around the flooded streets. Churchill Downs was not exempt from floodwaters, but the Kentucky Derby went on as scheduled the following May.

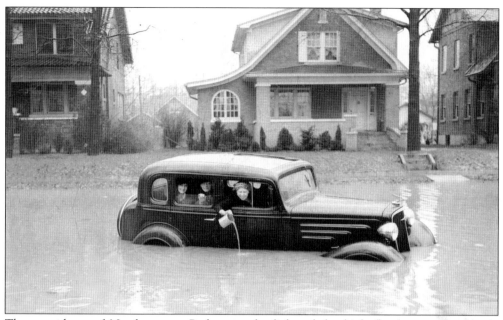

These residents of Northwestern Parkway make light of the high floodwaters that nearly submerge their car. The effects of the flood were felt for weeks with city power supplies cut off for days, and for up to two weeks to the downtown area.

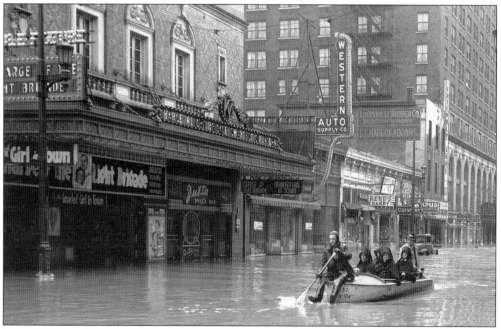

These Sisters of Charity of Nazareth make their way north on Fourth Street in a motorboat. The man in the front uses an oar to help guide the boat. The Brown Hotel is in the left rear of the photo, located on the corner of Fourth and Broadway.

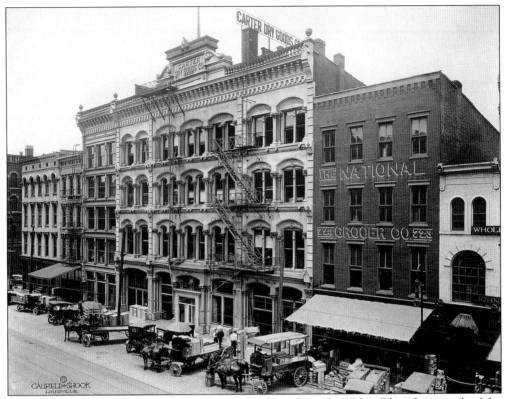

Shopping in Louisville took residents downtown throughout the 1950s. This photograph of the Carter Dry Goods Store was taken in 1922. The store, located at Seventh and Main Streets, was built in 1878. The building now houses the Louisville Science Center.

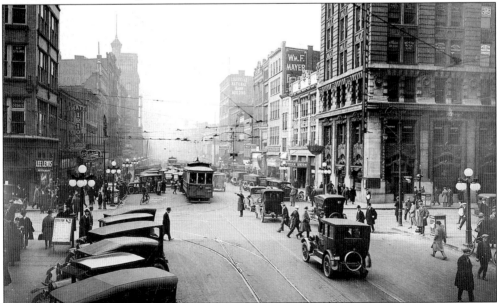

The 400 block of Market Street was a bustling center for shopping and business. This photo was taken in 1924 and shows the view west toward Fifth Street.

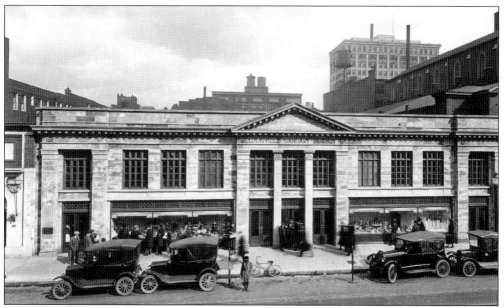

The Louisville Sanitary Market was located on Fifth Street, adjacent to the Cathedral of the Assumption. The market, which sold groceries and produce, is now the site of a parking garage.

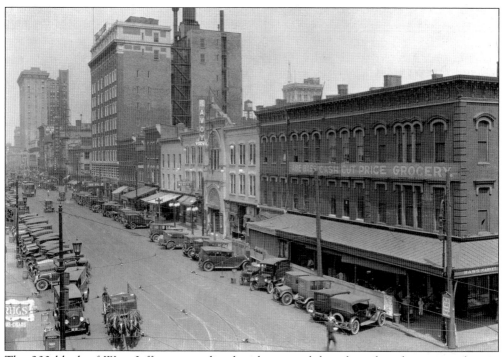

The 200 block of West Jefferson was lined with automobiles when this photo was taken in 1926. The Savoy Theater may be found in the strip of businesses shown. The block was demolished in the 1980s to make way for the Commonwealth Convention Center, now the Kentucky International Convention Center.

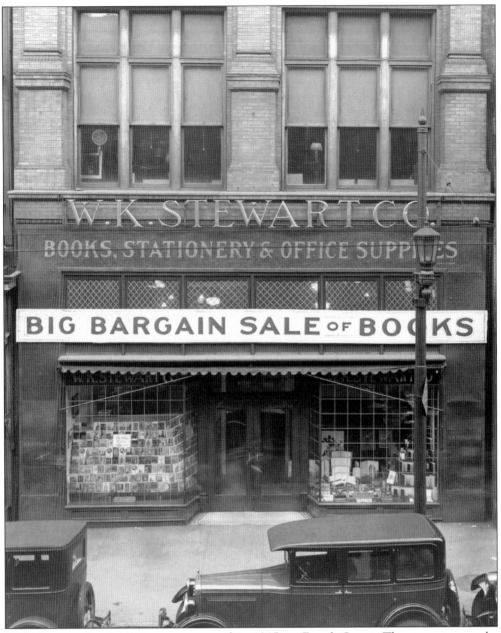

W.K. Stewart Co. Book Store was opened in 1915 on Fourth Street. The store was run by William Stewart, who would display his personal rare book collection for public view. Stewart also brought many art collections to Louisville for display and purchase, including works by Rembrandt and Whistler.

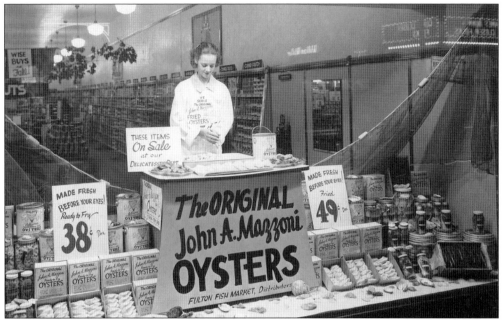

Mazzoni's Café was founded by Italian immigrant Phillip Mazzoni at 212 South Third Street in 1884. Originally a bar, the signature rolled oyster was offered free to customers. Following Prohibition, Mazzoni's became a restaurant with the rolled oyster as the centerpiece of the menu. Other local menus copied the dish, but Mazzoni's provided the original as advertised in this 1936 display.

Shoppers wait for service at the grand opening of the Kunz's Delicatessen at 619 South Fourth Street in 1941. This new location housed a restaurant, delicatessen, and family grocery. Although the restaurant was named "The Dutchman," J. Kunzman was Swiss. The restaurant is now located at Fourth and Market Streets.

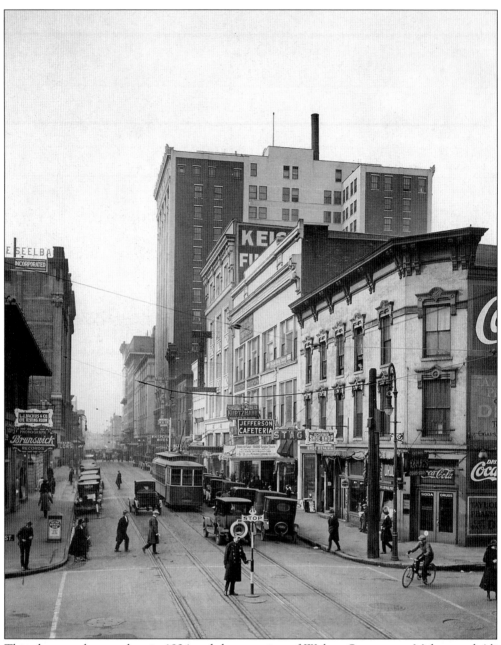

This photograph was taken in 1924 and shows a view of Walnut Street, now Muhammad Ali Boulevard, looking west from Third Street. A police officer is stationed in the middle of the intersection to manually switch the "stop" and "go" signs for traffic control.

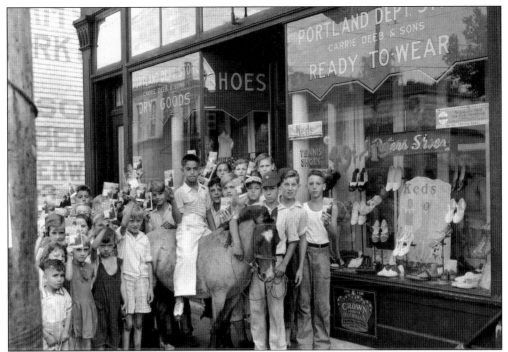

It was not necessary to travel downtown for all shopping needs. Many shops were located in neighborhoods and supplied groceries, hardware, clothing, and linens—also known as dry goods. In this photo, Portland Department Store, run by Carrie Deeb & Sons, sponsored a Keds shoe promotion to bring out the neighborhood children.

Highland Park was developed in 1889 as a workers' suburb for employees of the Louisville & Nashville (now CSX) Railroad yard and shops in south Louisville. The town was annexed to the city of Louisville in 1922. A small African-American community called Bucktown was populated by railroad workers and their families. This view shows Park Avenue in 1934. The entire neighborhood was relocated for a major airport expansion project, and the houses and other buildings demolished.

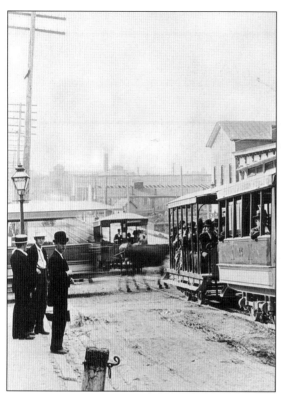

Mass transit was made available in Louisville by mule car, electric trolley, and bus. This car heads up Green Street (now Liberty) under its own power, as two mule-drawn cars pass in the background.

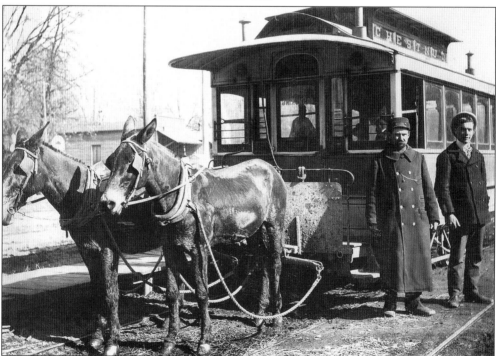

This is one of the last mule cars to operate in Louisville. Mules "Don" and "Jim" pose with their trolley and drivers on Frankfort Avenue.

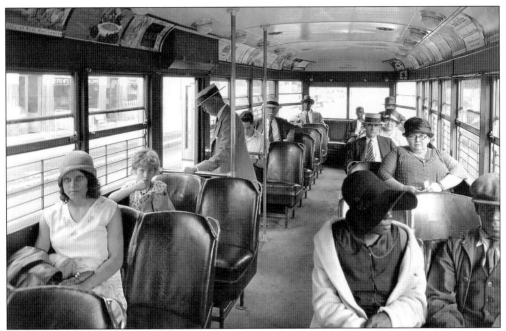

These passengers on a Louisville Railway Company trolley wait for the trip to resume as other passengers exit the trolley. The Louisville Railway Company operated trolleys from 1890 until May 1, 1948. The last cars in service carried race fans to Churchill Downs for the Kentucky Derby.

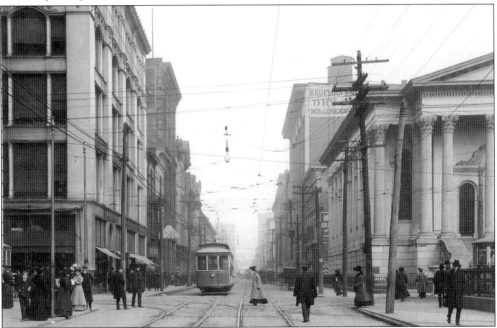

Trolleys made travel to downtown fairly easy and direct from neighborhoods across the city. However, the trolleys ceased operation in 1948 when ridership was diminished with the increase in personal automobile ownership. City buses, not limited to rail routes, were developed to provide mass transit.

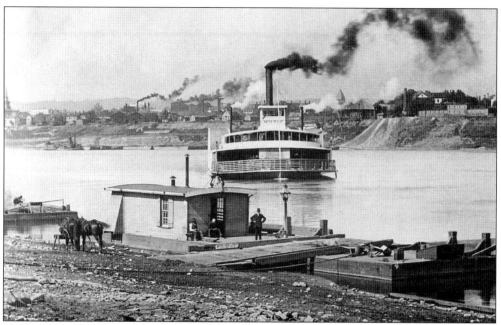

Transportation in and around Louisville has taken many forms. The Portland-to-New Albany ferry carried passengers and goods across the river. Here, a passenger waits for the arrival of the ferry to carry him across.

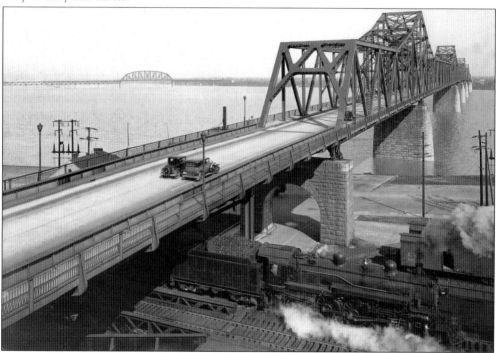

The Municipal Bridge, completed in 1929, was the first bridge exclusively designed for automobile traffic. The number of cars in Louisville and southern Indiana greatly increased after World War I. This view from 1931 shows the three main arteries of transportation in Louisville: the Ohio River, the railroad, and roads and bridges.

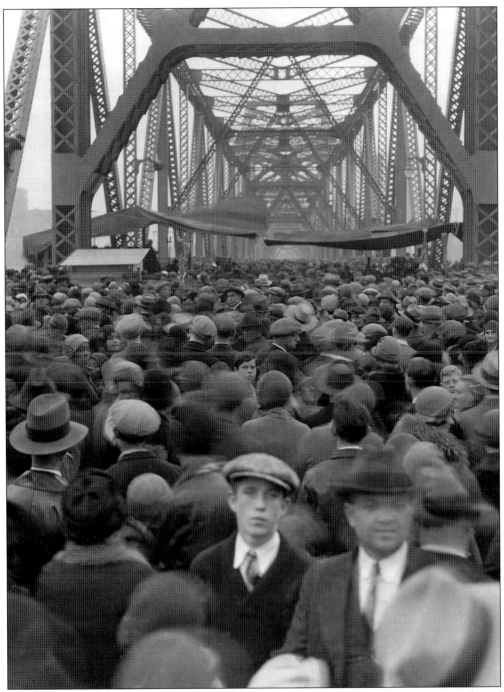

The dedication of the new Municipal Bridge in October 1929 brought out hordes of Louisvillians despite a constant cold drizzle. The bridge was designed by architect Paul Cret and the engineering firm of Modjeski and Masters of Philadelphia. Built at a cost of $4.7 million, it took one year to construct. Crossing the bridge required paying a toll, designed to offset the cost of construction. The construction of an automobile bridge had been discussed as early as 1919, but financing the project took most of the next ten years.

The Greyhound Bus terminal at Fifth and Broadway was designed by architect William Arrasmith. Arrasmith was nationally known for his art deco–style Greyhound Bus stations. The depot was demolished and is now the site of a parking lot. Surviving terminals designed by Arrasmith in other cities have been designated as historic landmarks.

The development of the interstate system in Kentucky had a great impact on many buildings and neighborhoods. The image below, taken by the Department of Transportation in 1959 at Brook and Kentucky, shows the construction of Interstate 65. Englehart Elementary School, on the left, is severed from the neighborhood it serves.

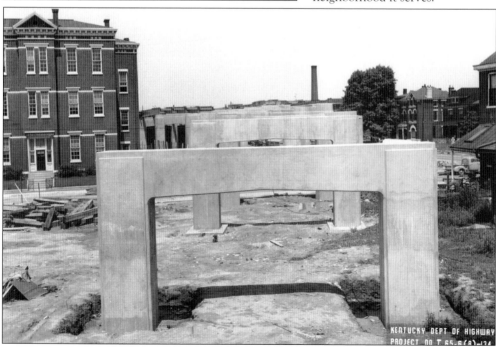

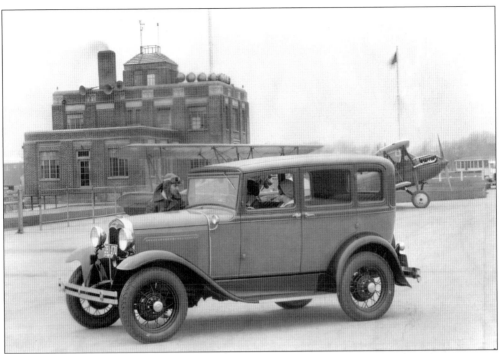

Bowman Field is the oldest airfield in Kentucky, established in 1919 by Abram H. Bowman on 50 acres leased from the U.S. government. The field was officially dedicated and named in 1923. The city purchased a 600-acre tract in 1927 to develop a municipal airport. The terminal was completed in 1929, and the runways were paved in 1937. The first passenger service began in 1931, and flights to Miami and Chicago were available on Eastern Airlines by 1934.

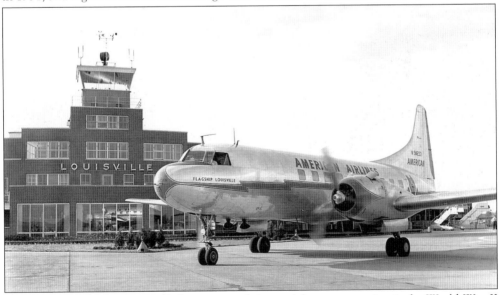

Standiford Field (now Louisville International Airport) began as an airstrip for World War II planes and became Kentucky's leading commercial airport in 1947. Lee Terminal was completed in 1950. Following the arrival of Standiford Field, Bowman Field became an airport for private planes.

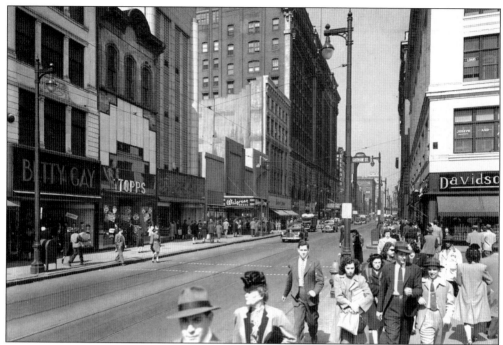

Fourth Street is filled with pedestrian traffic in this scene taken in 1947 near the corner of Guthrie Street. The trolley tracks are gone, and the road is completely given over to automobiles and buses.

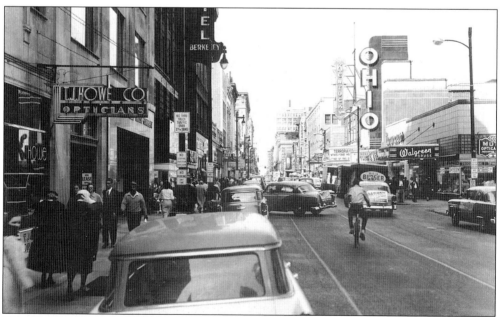

The development of a highway system and suburban developments in post–World War II Louisville had not yet affected the businesses on Fourth Street in this photograph from 1957. The Watterson Expressway was completed in 1958, creating a quick, direct route to and from the city from the suburbs. Over the next few decades, shopping developments were built in the suburbs, negating the need for shopping in the city.

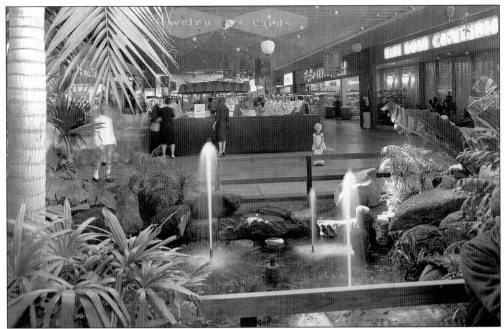

The Shelbyville Road Mall was opened in 1962 as the first mall in Kentucky. Located on land that was formerly part of the Arterburn family estate, the square building was situated on 67 acres with parking on all four sides. Downtown retailers did not view the new shopping development as a threat, and retailers such as Kaufman-Straus and Rodes opened stores in the development—it was an immediate success.

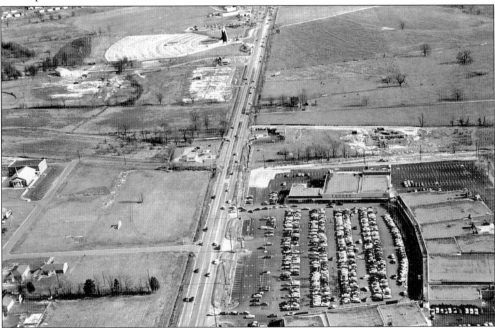

This view of Shelbyville Road from the Shelbyville Road Plaza, on the right, to the location of the present-day Watterson Expressway was taken by *Courier-Journal* photographer Billy Davis in 1954. The open land is now filled up with commercial and residential developments.

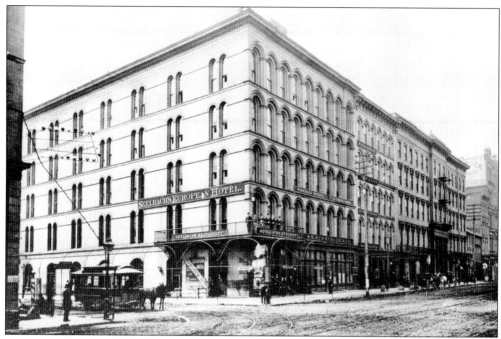

Main Street was a main thoroughfare through early Louisville. It was the location of warehouses, shops, and hotels—businesses catering to the needs of travelers on the Ohio River who had to go around the Falls. Many early businesses were occupied with the cartage and storage of goods. This 1880 view shows commercial buildings on Main Street west from Sixth.

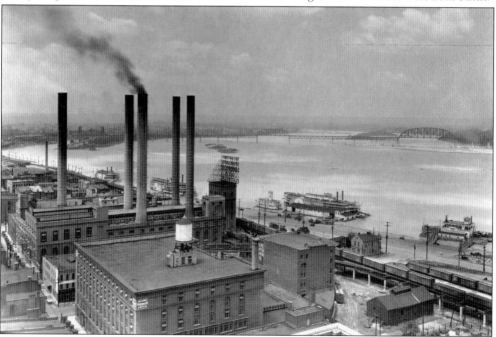

The Ohio River maintains an important role in industry and business into the 20th century. This photograph from 1926 shows factory smokestacks, billowing smoke as boats ply the river and the railroad runs parallel to the river.

Two
WORK IN LOUISVILLE

Louisville's early business economy was driven by the reality that every traveler on the Ohio River had to stop at Louisville because of the Falls of the Ohio. Many early businessmen made their living transporting freight and travelers around the falls. Hotels and restaurants were established to meet the traveler's needs. Other early Louisvillians were occupied with the warehousing of goods in transit. There were numerous opportunities related to the shipping and transport businesses.

The city, during the first decades of the 19th century, was a point of distribution throughout the midsection of North America. The completion of a canal at Portland in 1830 allowed fairly predictable river traffic for the first time since settlement. The existence of a canal caused a shift in the local economy and influenced the beginning of widespread manufacturing interests in Louisville.

By 1926 the city was home to 20 manufacturing plants recognized as the largest in the South, the United States, or, in some instances, the world. Companies recognized as the largest of their type in the world included Belknap Hardware and Manufacturing; Adler Manufacturing Company, maker of reed organs; and the Hillerich & Bradsby Company, the largest maker of baseball bats. The distribution of goods by river, rail, and air has continued to play an integral part in Louisville's economy.

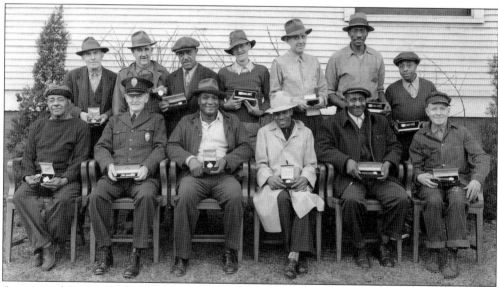

A group of Louisville Cooperage employees, possibly retirees, pose with their gold watches awarded for service. The cooperage industry in Louisville supplied shipping and storage containers to the distilling and tobacco industries. Wooden barrels were used for packing and transporting a variety of goods.

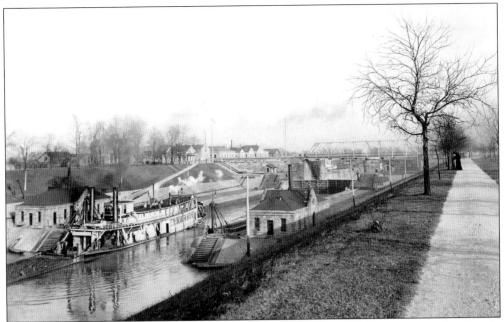

This photograph was taken in 1905 of the canal in Shippingport. Shippingport was the site of a shipyard run by the Tarrascon Brothers, a flour mill, and numerous shops and businesses. The Louisville and Portland Canal was built between 1825 and 1830 to allow boats to bypass the Falls of the Ohio. This construction separated Shippingport from the mainland, and a bridge across the canal was built to provide access to the rest of the city.

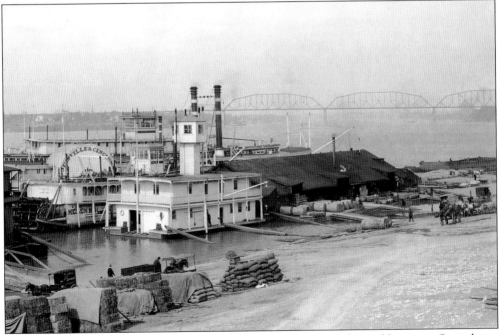

A 1905 photograph shows the Louisville Wharf as a bustling place of business. Steamboats would routinely dock to unload goods and passengers. The goods were off-loaded onto the wharf and loaded onto wagons for transport to their final destination.

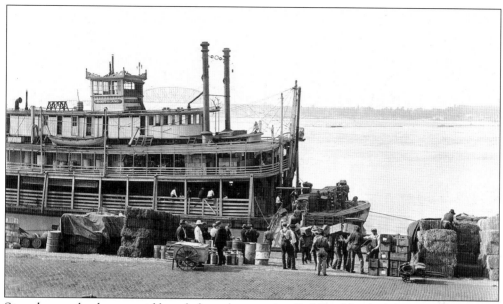

Stevedores unload crates and barrels from the steam packed Southland while ten-gallon cans of milk wait to be loaded. On its Texas deck, the Southland sports a pair of antlers, usually awarded to the winner of a steamboat race. As late as 1926, the wharf at Louisville was a main distribution and shipping center for goods traveling on the Ohio River.

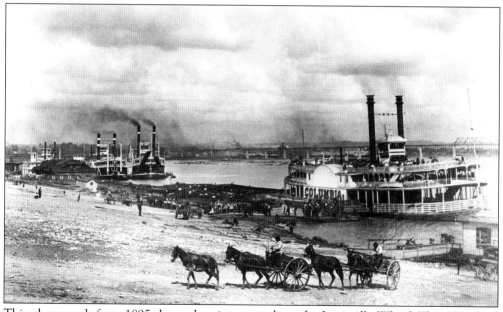

This photograph from 1895 shows the view west along the Louisville Wharf. The side-wheel steamboat Columbia was built in Jeffersonville, Indiana in 1892 and served both as the Louisville and Jeffersonville Ferry and as an excursion boat. Other steamboats are lined up along the wharf loading goods manufactured in Louisville and unloading raw materials and other merchandise for the Louisville market.

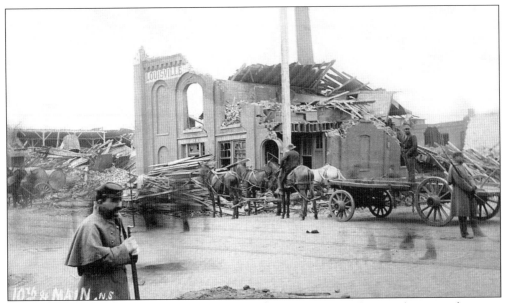

The Tornado of 1890 left devastation in its wake. The funnel cloud destroyed 32 manufacturing plants, 10 tobacco warehouses, 532 dwellings, 5 churches, 7 railroad depots, 2 public halls, and 3 schools. One hundred people were killed by the "great cyclone." This view at Tenth and Main shows workers hauling debris away in a wagon and armed militia maintaining order.

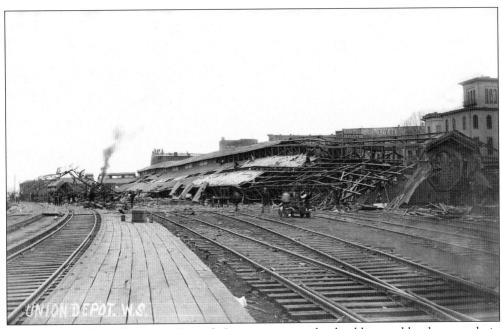

Train sheds at Union Depot on Seventh Street were completely obliterated by the tornado in 1890. In this photograph, workers assess the damage at the site and begin the clean up. The citizens of Louisville bounced back from the tornado with no outside help. The city refused offers of federal dollars and assistance from the Red Cross.

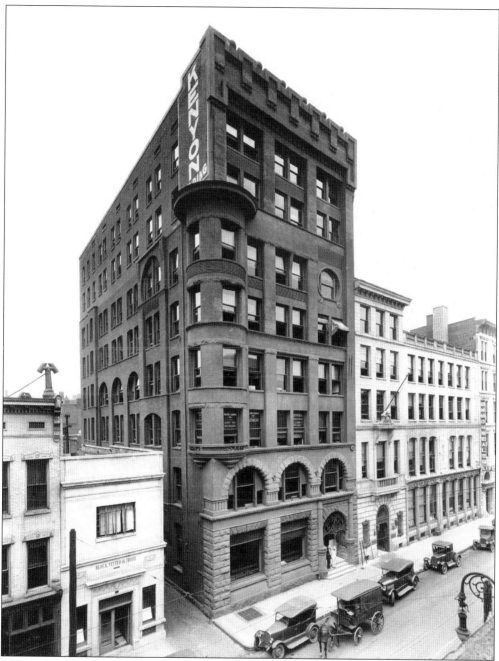

The Kenyon Building at 112 South Fifth Street was built as Louisville's first skyscraper. The six-story brick building was designed by architect Mason Maury in the Richardsonian Romanesque style. This photograph was taken in 1927; the building was demolished in 1974.

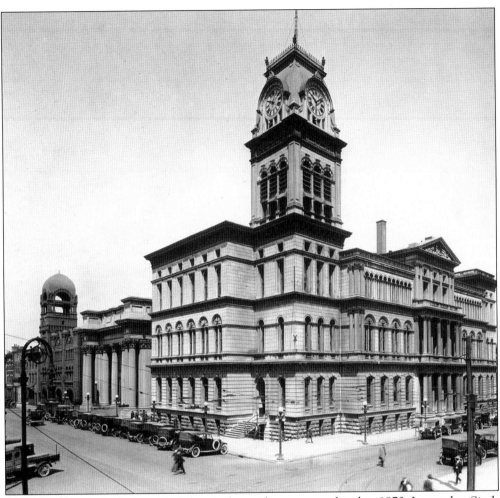

Louisville's city hall, designed by John Andrewartha, was completed in 1873. Located at Sixth and Jefferson Streets, it was the first building designed for city government offices. Prior to city hall's completion, all government offices were housed in the Jefferson County Courthouse across the street. The stone building features a carved train and the heads of cows, horses, and sheep to showcase the prosperity of this river city. The city hall is topped by a large clock tower, the first in the community. The county courthouse's original design by Gideon Shryock called for a clock tower, but it was never completed. Adjacent to the city hall on the left are the police department headquarters with the large columns, and the fire house topped by a hose tower. This photograph was taken in 1922.

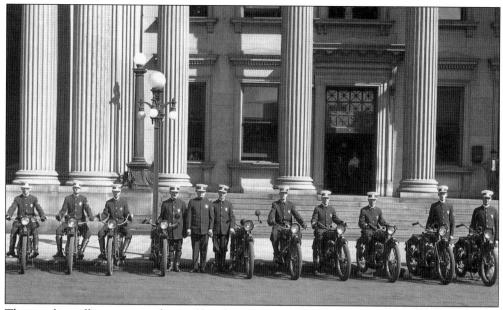

These police officers pose in front of headquarters in 1920. The Louisville Police Department traces its roots to 1785 when the first police officer was hired to patrol the city streets at night. The role of the department developed over the next 100 years and evolved to include officers on horseback, bicycles, motorcycles, and automobiles.

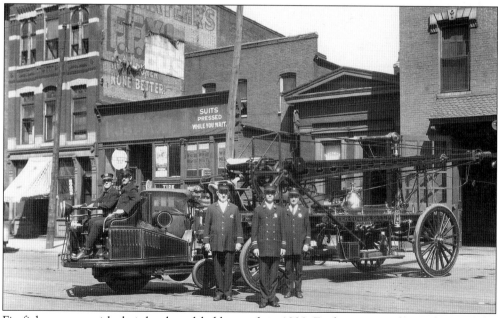

Firefighters pose with their hook-and-ladder truck in 1920. Firehouses were located around the city to provide protection to residents. A fire-training school was established in the city in 1919, and a Fire Prevention Bureau was started in 1921.

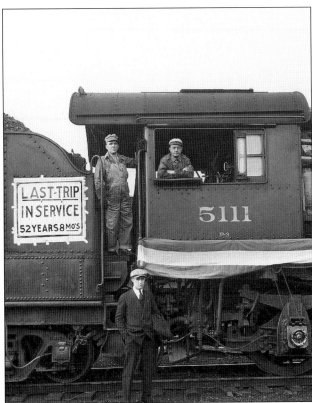

Railroads have played an important role in developing business in Louisville since the 1850s. The Baltimore & Ohio (B&O) crossed the Ohio River to Cincinnati and beyond. This photograph, taken in 1930, records the retiring of a B&O steam engine.

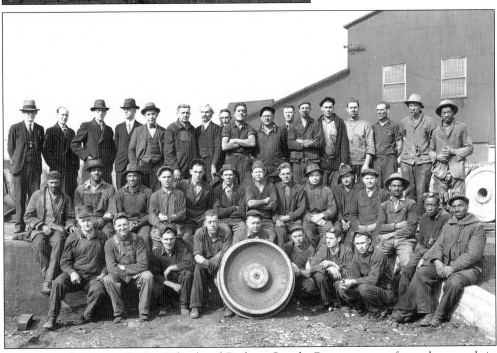

Workers at the Louisville Car Wheel and Railway Supply Company pose for a photograph in 1933. The company was located at 615 West Shipp Street near Hill Street in Old Louisville.

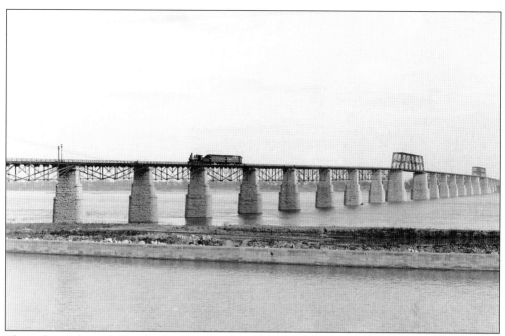

The railroad depended on bridges to cross the Ohio River for access to northern markets. The Fourteenth Street railroad bridge was designed by Albert Fink and completed in 1870. Albert Fink was an engineer for the Louisville & Nashville Railroad. He was also hired in 1853 to complete the Jefferson County Courthouse at Fifth and Jefferson Streets. Using the skills learned as a bridge builder, Fink used cast iron throughout the interior of the courthouse.

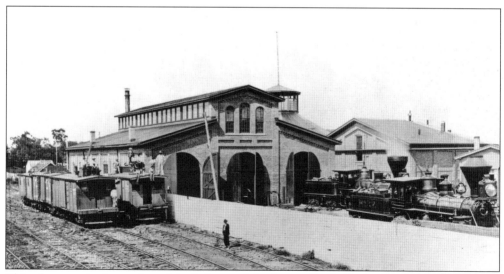

This photograph shows the original shops of the Louisville & Nashville Railroad located at Tenth and Kentucky.

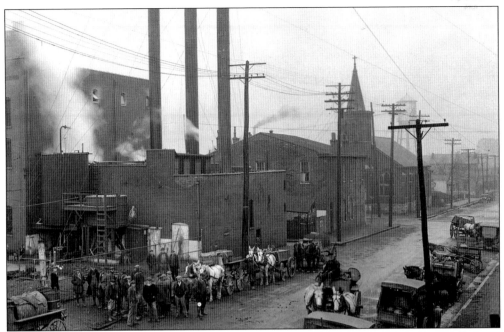

The Stitzel Weller distillery, pictured in 1931, was located at 1035 Story Avenue. Farmers brought wagons to the distilleries to purchase mash to feed to their livestock. Mash is a by-product in the distilling process that consists of fermented corn, the basis for whiskey and bourbon.

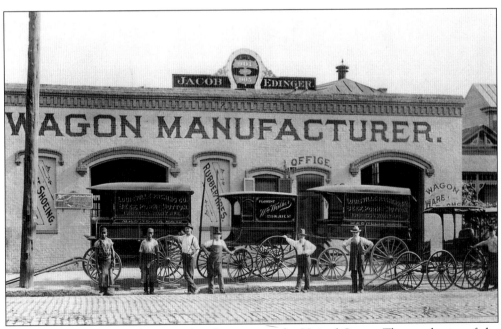

Louisville was a center of wagon manufacturing in the United States. The employees of the Jacob Edinger Wagon Works show off the quality of their wagons in this photograph from the 1890s. Established in 1870, the firm still exists as a manufacturer of specialty truck bodies.

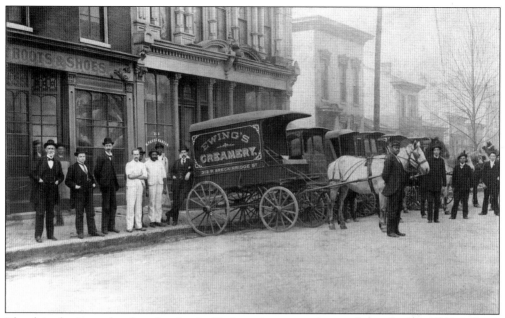

The dairy business developed as Louisville became more urban and city dwellers did not have enough land to graze a cow. The dairies grew up on the outskirts of the city and delivered milk door-to-door on routes within a manageable range. Daily milk delivery was the norm until home refrigeration was made widely available.

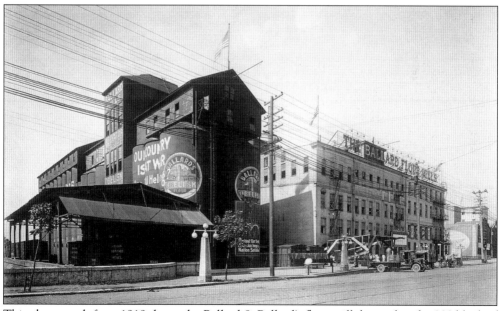

This photograph from 1919 shows the Ballard & Ballard's flour mill, located in the 900 block of East Broadway. The Ballard Company was known for its ready-to-bake canned biscuits and for developing advertising tools that included a live jug band that performed around the city.

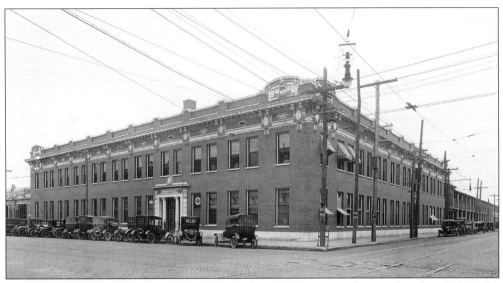

The Bourbon Stock Yards was the oldest in the United States when it closed in 2000. The office at Main and Johnson Streets was built in the latter part of the 19th century with office space for commission merchants, loading docks, and other amenities. The Bourbon Stock Yards dominated the cattle market in Kentucky.

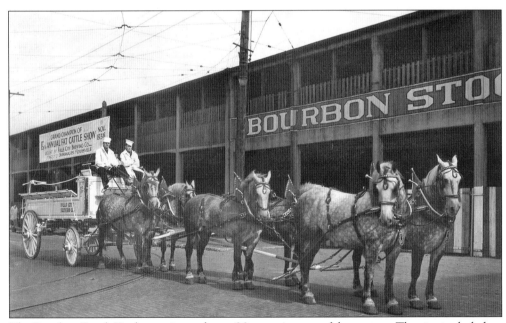

The Bourbon Stock Yards was situated on a 20-acre site east of downtown. The site included an office building and animal pens and chutes. This photograph, taken in 1936, shows the Falls City Brewing Company wagon at the company-sponsored cattle show at the stock yards.

Louisville's location on the Ohio River and its role as Kentucky's main river port brought agricultural products such as corn, tobacco, hemp, cattle, and hogs to the city. Slaughtering operations for beef and pork were in operation as early as the 1820s. This photograph of the Fischer Packing Company from 1936 shows meat inspectors inside the plant.

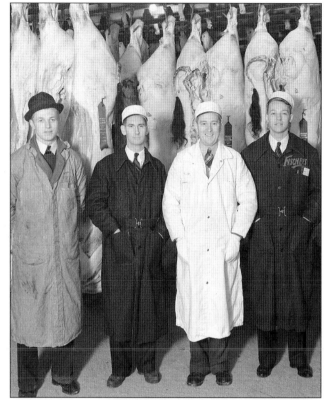

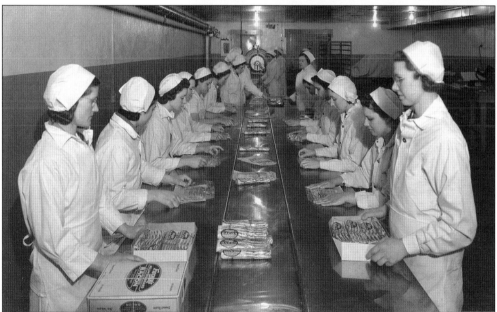

The meatpacking industry in Louisville was centered in Butchertown. The Fisher Packing Company is located on Mellwood Avenue. This photo from the 1930s shows women packing bacon. The company became known for its advertising slogan, "The Bacon-makin' People," created by Louisville advertising agency Doe Anderson, which was founded in 1915.

This photograph shows the diversity of wood wares produced by the Hillerich Wood Turning Company in the late 19th century. The company made bed and porch posts, banisters, trim, and a patented butter churn. The company began making baseball bats in 1884 and the focus of the business moved to bat making and other sports equipment when the company became Hillerich & Bradsby in 1916.

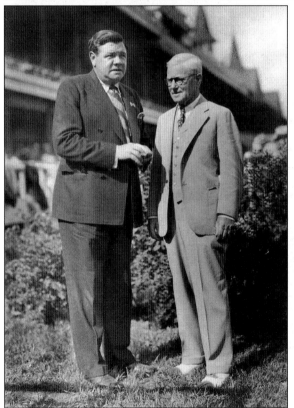

Baseball players from all over the United States purchased wooden bats from the Hillerich & Bradsby bat factory. One of the most famous to use a Louisville Slugger was Babe Ruth, shown here as the guest of Bud Hillerich at the 1934 Kentucky Derby. A Louisville Slugger bat used by Ruth, complete with notches for each home run, is on display at the company's Slugger Museum.

Baseball great Ted Williams used Louisville Slugger bats exclusively during his career. He made frequent visits to the bat factory, choosing the billets of wood from which his bats were made. Williams looked for wood with pin knots, which he believed made a harder bat. This photograph from 1942 shows him trying out a bat at the factory.

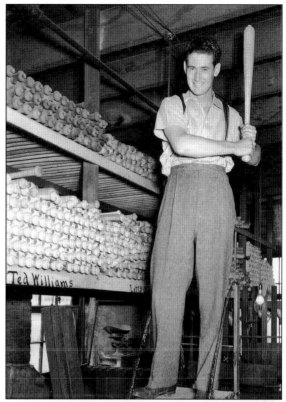

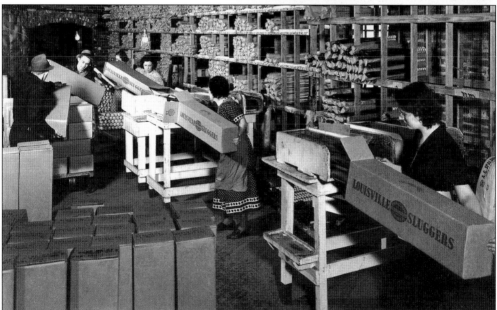

One million Louisville Slugger bats were produced in 1923, and the company began making Powerbilt golf clubs in 1933. The company was called into service during World War II to make gun stocks and billy clubs. Other products, including Louisville Hockey equipment, have been added over the years. These women are packing bats for shipping.

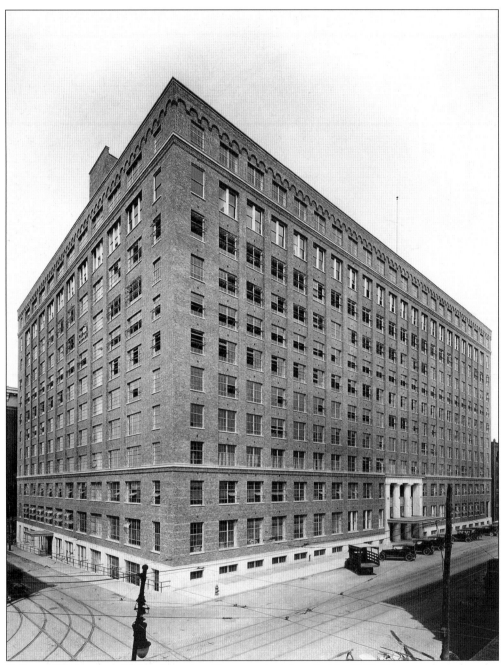

Belknap Hardware and Manufacturing Company was founded in 1880. The company became the largest wholesale hardware manufacturing company in the world as its line grew to include 90,000 items, such as church bells, revolvers, table knives, horse collars, and toys. The company occupied a 40-acre site with 14 buildings, many of which have now been demolished. It closed in 1986 following financial difficulties and the site was purchased by Humana, Inc., who renovated the building shown in this photograph as its Waterside headquarters. Two other buildings were donated to the Presbyterian Church, USA as its headquarters.

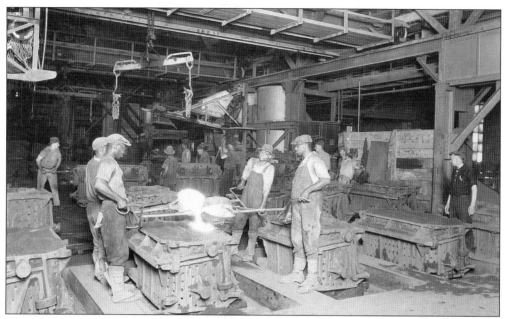

Manufacturing work in Louisville often included heavy lifting and extreme temperatures. These men are working in the foundry at the American Standard Plant in the 1920s. Standard was a union shop, as were many Louisville manufacturing plants, and labor-management relations were often strained. The unions struck the company several times over issues related to contract renewal.

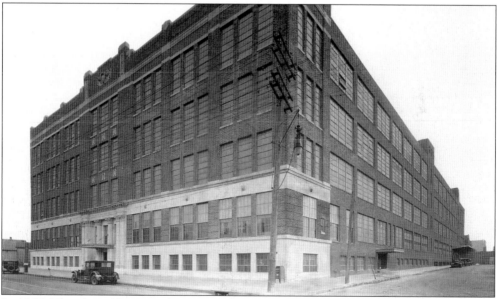

In 1865, Theodore Ahrens and Henry Ott began the Ahrens and Ott Plumbing Company, makers of plumbing fixtures and pipe fittings. The company grew into the American Standard Company, the largest manufacturer of bathroom and kitchen fixtures and fittings in the world. Company innovations included the one-piece toilet and combination faucets. The factory was located on Seventh Street at Shipp and included 60 buildings on 53 acres. The Louisville plant was closed in 1992, due to changing markets for fixtures.

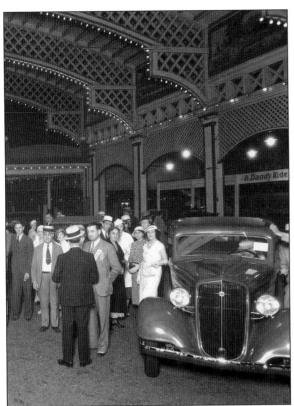

New Chevrolet models were introduced at this car show in 1934. The show was held in the entrance pavilion at Fontaine Free Park, an amusement park formerly in Louisville's west end.

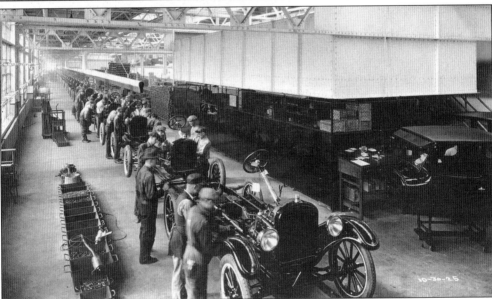

Ford Motor Company workers assemble Model Ts at a plant on South Western Parkway. The factory was originally located on Third Street in 1913. In 1916 it was moved to the intersection of Third Street and Eastern Parkway. The factory shown here was on a 20-acre site opened in 1925. The plant produced military vehicles from 1942 to 1945. Two newer plants produce large trucks and the popular Ford Ranger.

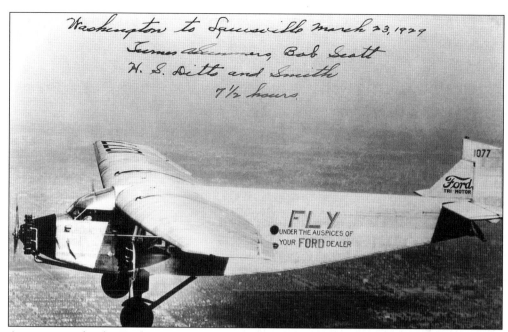

A promotion for the Ford Motor Company featured an airplane flight from Washington, D.C. to Louisville in March 1924. The plane was painted with the tag line, "Fly Under the Auspices of Your Ford Dealer."

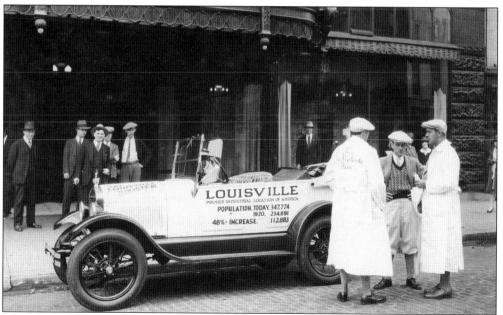

Promotion of Louisville as a site for business is not a new enterprise. The Ford Motor Company provided a car and partnered with the *Louisville Times* to drive cross-country as "Louisville Boosters." Photographer R.G. Potter and E.J. Lucas of Ford drove from Boston to Milwaukee publicizing Louisville's assets and resources. The cost of operating the car for the 3,000-mile trip was $47.20, including the gasoline.

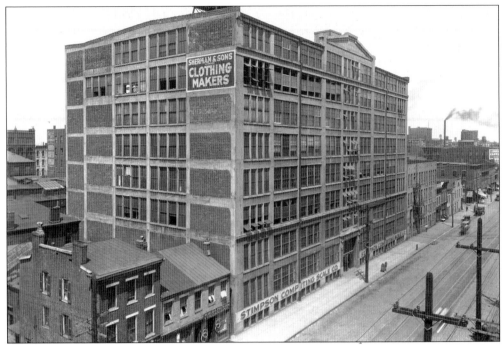

The Snead Building at Ninth and Market was a speculative building, designed to house a variety of businesses. It was constructed of poured concrete and is on rockers to accommodate movement caused by huge presses operated in the building. The building has been rehabilitated as residential lofts, office space, and the Glassworks museum and factory.

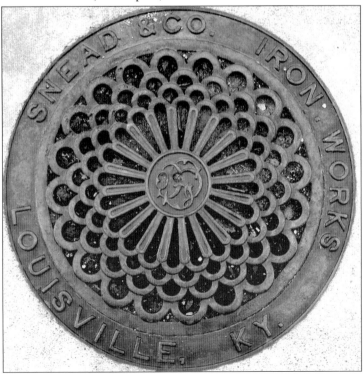

The Snead Iron Works, which constructed the Snead Building, made manhole and coal hole covers in a variety of designs.

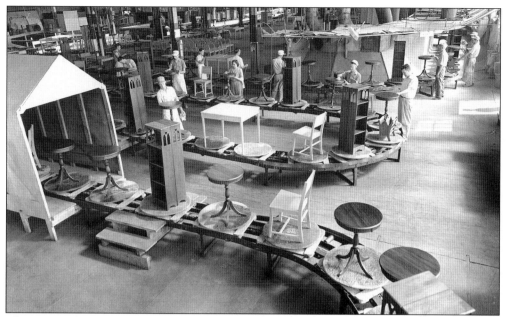

The Mengel Company was started in 1877 as a box-making company. They used local and regional hardwoods and made boxes for shipping tobacco and distilled products. The company expanded to operate plants in St. Louis, Winston-Salem, and Jersey City, New Jersey, and to harvest wood from Africa and Mexico. This photograph shows the furniture division in 1944.

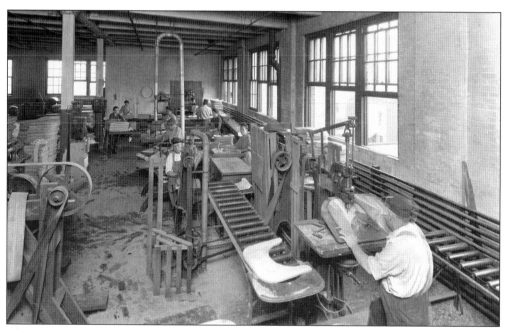

The Mengel Company produced wooden dash boards for automobiles at its plant at Fourth and G Streets. Changing markets, increased competition, and dwindling supplies of wood led to a merger with Container Corporation of America in 1960.

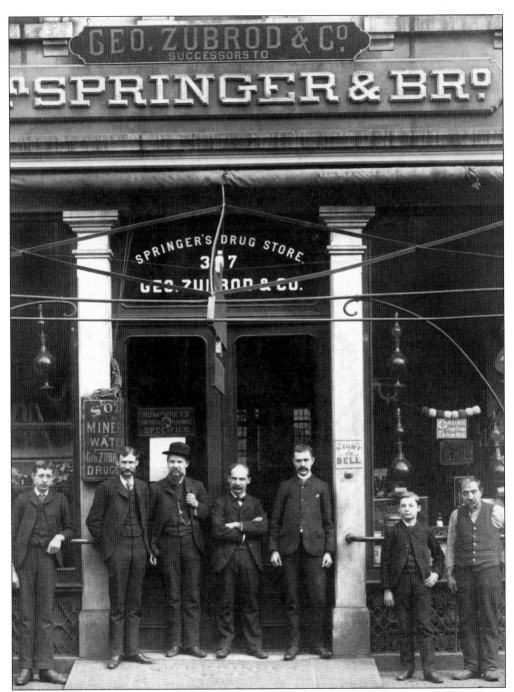

Local pharmacies and shops were located first on Main and Market Streets. This photograph shows the Zubrod & Co. Drug Store at 307 West Market Street in the 1880s. Louisville pharmacists lobbied for legislation to mandate specified training for those in the profession.

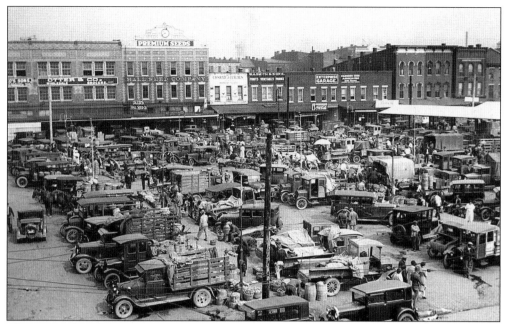

The Haymarket was the central location where farmers and truck gardeners brought produce for wholesale and consumer sales. It was founded in 1891 on a city block bounded by Jefferson, Liberty, Brook, and Floyd Streets. The increase of chain groceries hurt the businesses, and the construction of I-65 closed the market in 1962. This image from the 1920s shows the market in full swing.

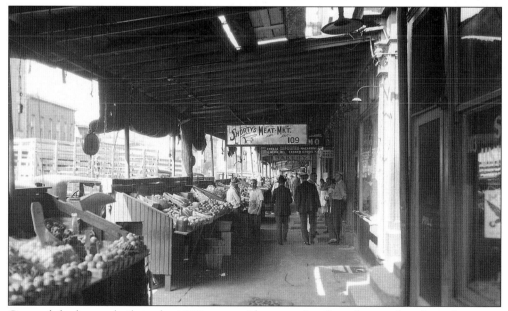

Covered sheds were built in the 1920s to provide protection from the weather. Large bins were constructed to hold fresh produce. Many of the vendors at the market were of Italian, Lebanese, and German descent.

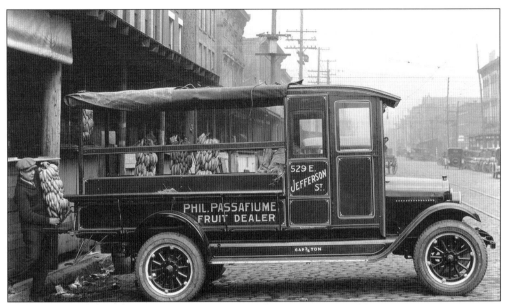

Phil Passafiume had a fruit stand adjacent to the Haymarket on East Jefferson Street. In this photograph, taken in 1926, one of his employees loads bananas onto a company truck.

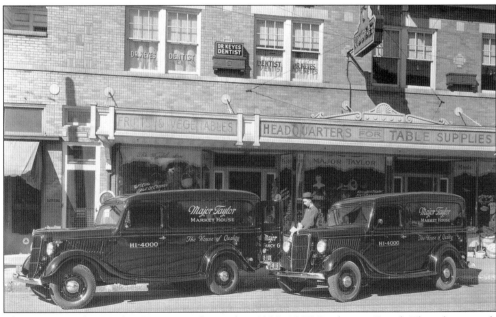

The Major Taylor Market House was located at 1303–1305 Bardstown Road. This photograph from 1936 shows two delivery trucks, which were used to deliver groceries.

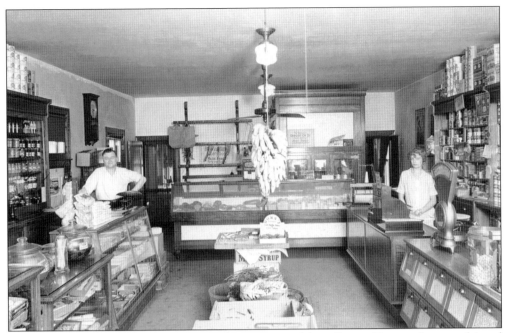

The first grocery in the city was opened in 1783 on Main Street. Dry goods were shipped downriver to Louisville on flatboats to stock groceries, and the owners often accepted corn or tobacco or other farm produce in payment. By the 1830s small neighborhood grocers such as this one, shown in 1926, were located across the city.

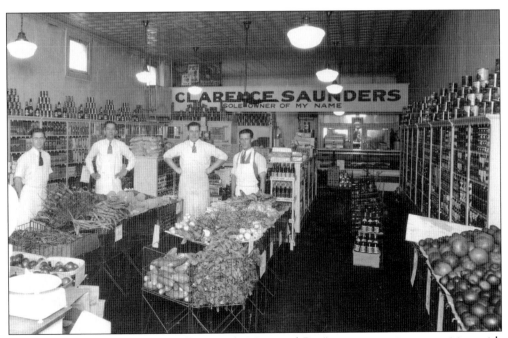

By the middle of the 1920s, locally owned "Mom and Pop" stores were in competition with national chain markets such as Clarence Saunders's self-serve Piggly Wiggly stores.

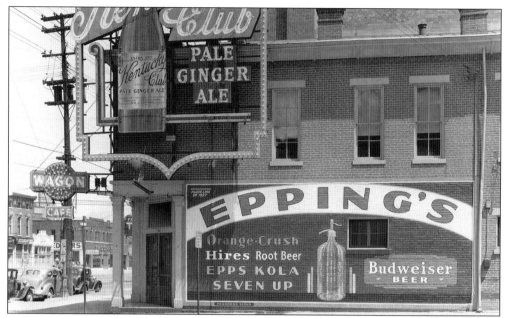

Soft drinks were manufactured in Louisville from the 1830s, but the Temperance Movement and improved sanitation and technology gave the industry a boost from the 1890s to the 1910s. Soda pop was made by several companies, including Parfay and Mel-Ola brands. The Epping Company was started in 1863 and bottled 7-Up, Orange Crush, and other soft drinks. The plant and brands were purchased by Pepsi-Cola in 1967.

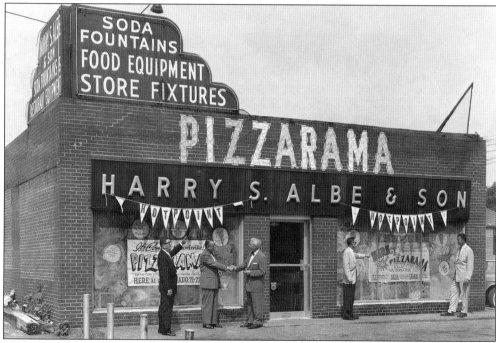

Restaurant supplies were provided by Harry S. Albe & Son at the "Pizzarama." The store catered to the restaurant and soda fountain trade. Following World War II, Louisville experienced an increase in restaurants and lunch counters.

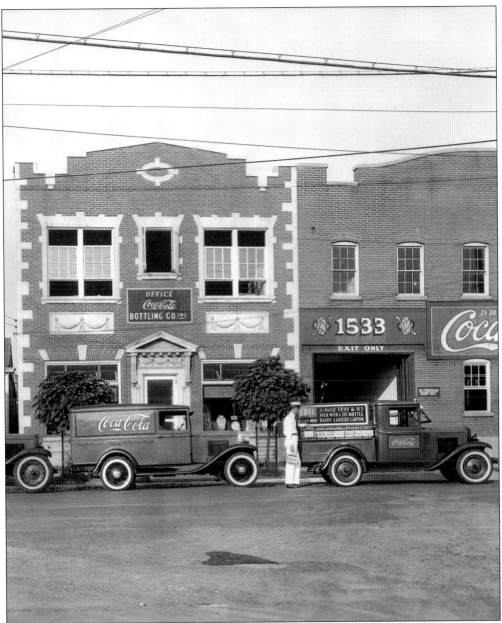

Coca-Cola was invented in Atlanta, Georgia, but sold by local bottling franchises. The second franchise in the nation was sold in 1901 to Louisvillian Fred Schmidt who established a bottling plant on Main Street. Syrup was shipped to the plant where it was diluted with soda water and bottled. The plant moved to 1533 Bank Street in 1912, and to a much larger facility in 1941 at Sixteenth and Hill Streets. The plant closed in 1991 and the operation transferred to Cincinnati. This photograph shows the plant on Bank Street and a fleet of delivery trucks.

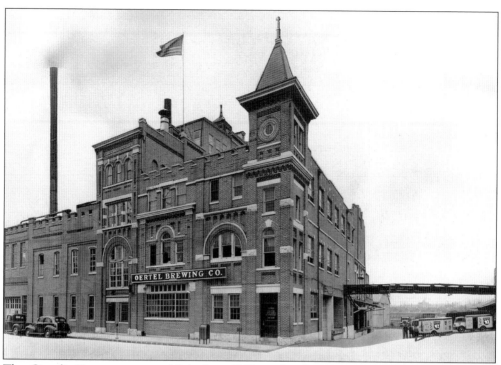

The Oertel's Brewery was established in 1892 in Butchertown. It was one of only three Louisville breweries that survived Prohibition. Along with the Fehr's and Falls City breweries, Oertel's made soft drinks and manufactured ice during Prohibition to stay in business. The plant at 1400 Story Avenue has elements of a Bavarian castle.

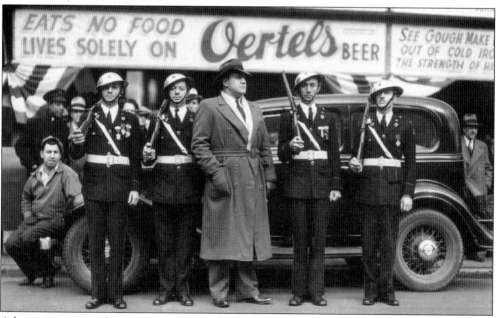

Advertising gimmicks were often used to promote brewery products. In this photograph an armed guard escorts Galen Gough to a series of free health lectures sponsored by the Oertel's Brewery. According to claims on the banner, Gough relied solely on Oertel's beer for nutrition.

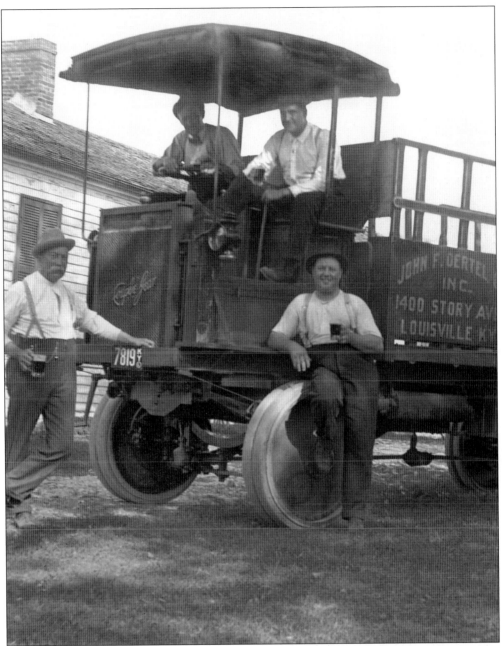

Many breweries operated in Louisville throughout the 19th and early 20th centuries. English, Scotch, Swiss, and German immigrants began breweries to supply taverns and for limited distribution by wagon. The widespread availability of ice-making machines in the 1880s allowed beer to be refrigerated and aged year-round. This led to the establishment of numerous local breweries, including Frank Fehr, Senn & Ackerman, Falls City, and Oertel's. In this photograph, John F. Oertel Brewing Company employees take a break on a new truck.

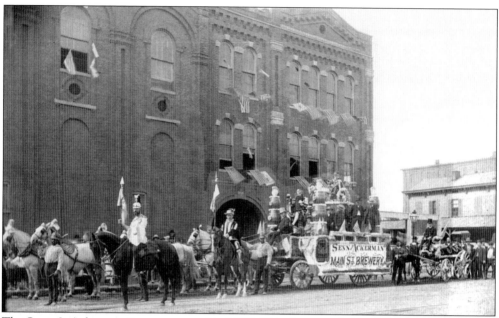

The Senn & Ackerman Brewery opened in 1877. This photograph from the 1890s shows a beer wagon decorated for a parade or presentation pulled by a team of eight white horses and accompanied by a full honor guard.

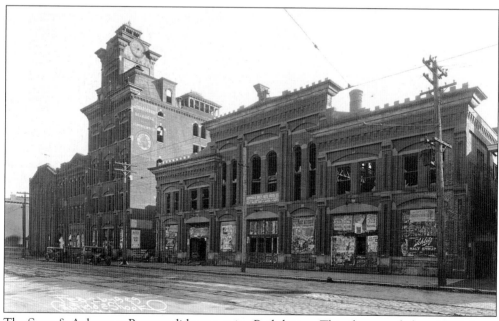

The Senn & Ackerman Brewery did not survive Prohibition. This photograph from 1929 shows the abandoned building at Seventeenth and Main with the windows broken out and graffiti on the walls.

The Falls City Brewery was located at 3050 West Broadway. The brewery was opened in 1905, and survived Prohibition by producing soft drinks and beer with a low alcohol content.

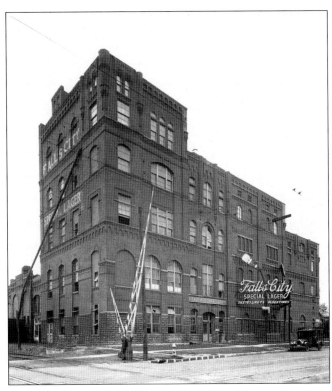

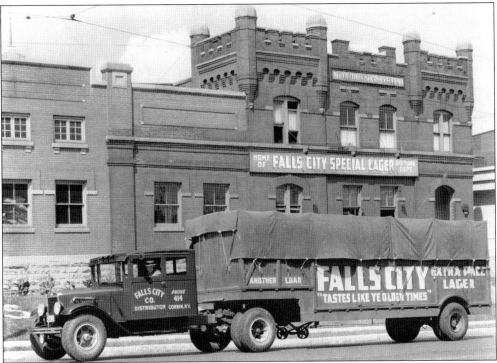

Breweries were often designed to resemble castles. Here, the Falls City delivery truck is photographed at the plant on Broadway. Note the towers above the entrance.

A carton packing line is pictured at Brown and Williamson Tobacco Corporation. In the 1960s, B&W manufactured over 100 million cigarettes daily at its Louisville plant.

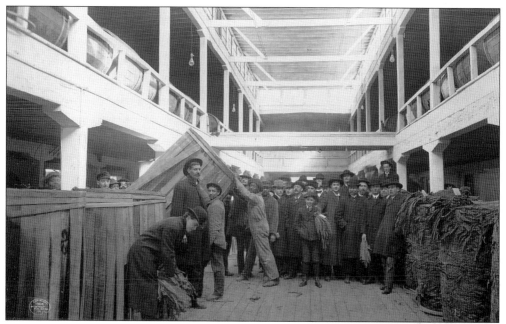

Inside a tobacco warehouse the raw tobacco is stored in large wooden casks called "hogsheads." Tobacco was grown across the state and manufactured into cigars, cigarettes, and other products. West Main Street was known as the "Tobacco District.".

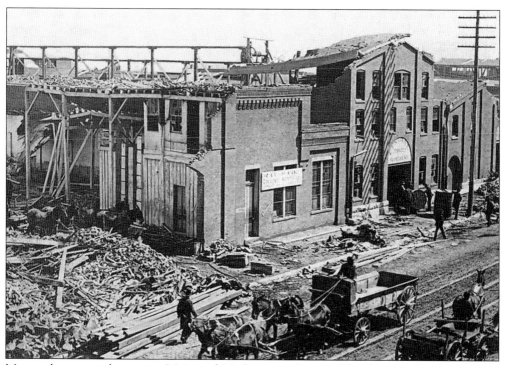

Many tobacco warehouses on Main and Market were destroyed by the tornado of March 27, 1890, but by 1892 the city directory reported that "no visible trace of the disaster remains."

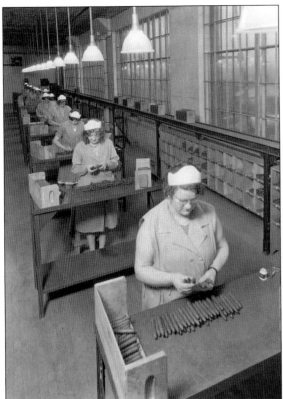

These women are making Cremo cigars in 1930. The cigars were advertised as more healthy than others because the cigar rollers did not use saliva to seal the roll. This was an effective advertising campaign in the days when tuberculosis, which is spread by exposure to an infected person's saliva, was widespread.

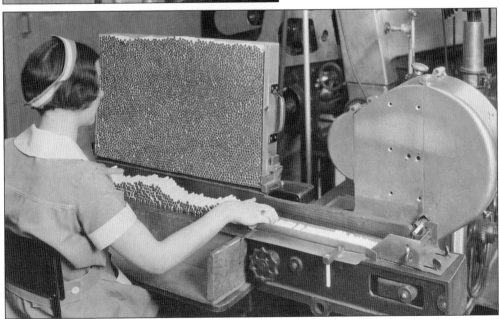

Women are busy operating cigarette-making machines at Axton-Fisher Tobacco Company. Family-owned Axton-Fisher was a major cigarette manufacturer with national brands including Spud, the first mentholated cigarette. The company was sold to Philip Morris in 1944 when one of the owners died and the other retired.

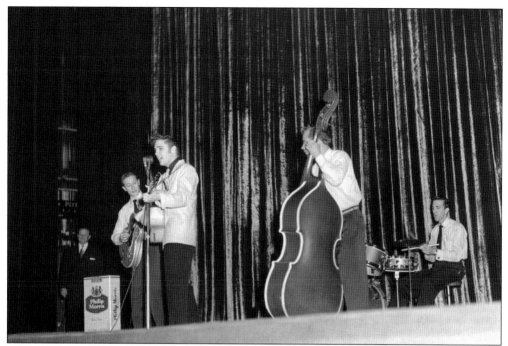

Philip Morris sponsored a country music show for its employees at the Mary Anderson Theater in 1955. The headline act was Hank Snow, and Elvis Presley was the opening act. These concerts grew into the Kentucky Derby Festival of Stars sponsored by Philip Morris and free to the public.

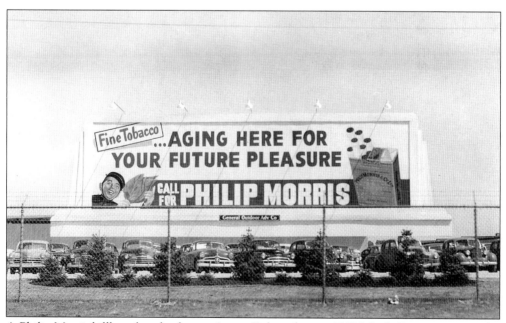

A Philip Morris billboard at the former Axton-Fisher plant at 1930 Maple Street promotes the quality of the company's product, which is aged "for your pleasure."

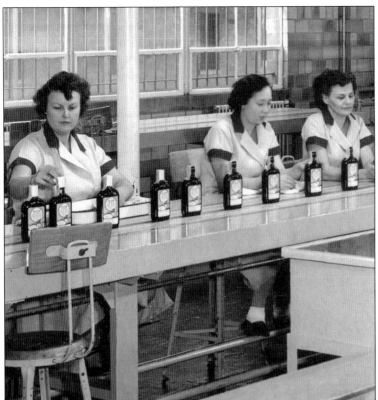

The Park & Tilford Distillery was located at 445 North Thirty-fifth Street. This photograph from 1949 shows women working on the bottling line.

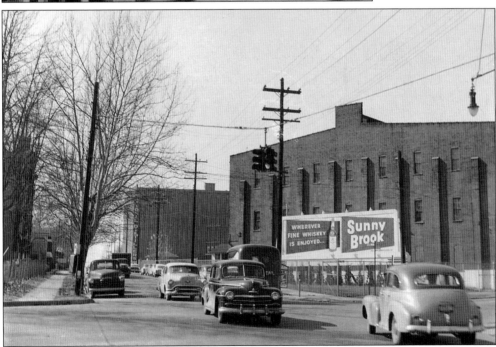

These buildings, now known as Distillery Commons, were whiskey warehouses for the Sunny Brook Distillery when this photograph was taken in the late 1940s.

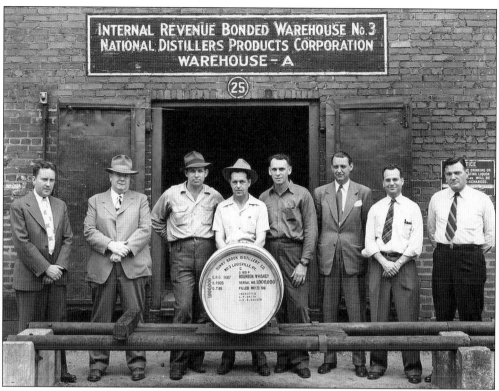

The revenuer poses with employees of National Distillers in front of Warehouse A. Each distillery was required to provide space for a federal employee who confirmed that the bottles were counted and properly stamped for sale.

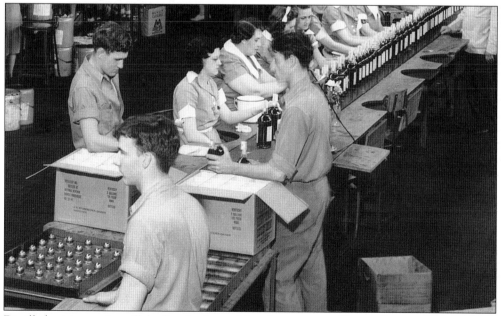

Distilled spirits coming off the line in the packing department at Brown-Forman Corp. are seen here in 1938.

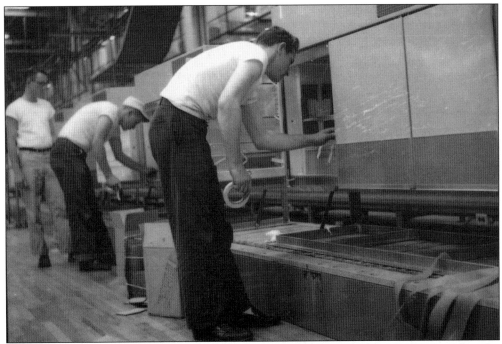

Workers are busy on the commercial refrigeration line at General Electric. GE moved to the Louisville area in 1949 and built Appliance Park manufacturing plant on the city's outskirts.

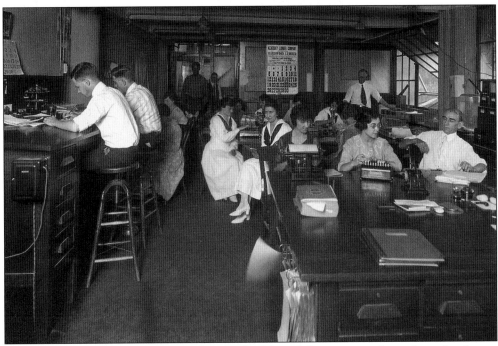

A 1920 photograph shows office workers at the Mengel Company, makers of wooden boxes, automobile bodies, furniture, toys, and other wood products. The company's box factory, on Dumesnil between Eleventh and Twelfth Streets, was the largest in the world.

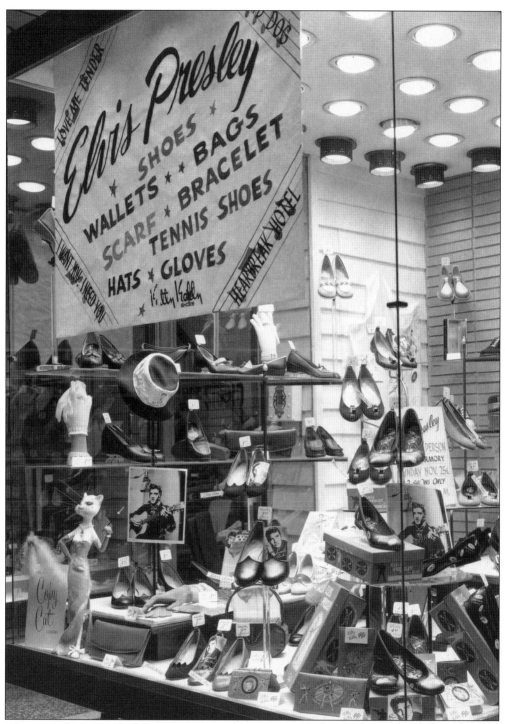

On November 9, 1956, the Kitty Kelly shoe store window on 434 South Fourth Street featured a line of merchandise for women including hats, gloves, and wallets by "Copy Cat"—the well-dressed feline in the lower left window. Store window displays had been turned into an art form by Louisville retailers such as Stewarts Dry Goods and Bycks.

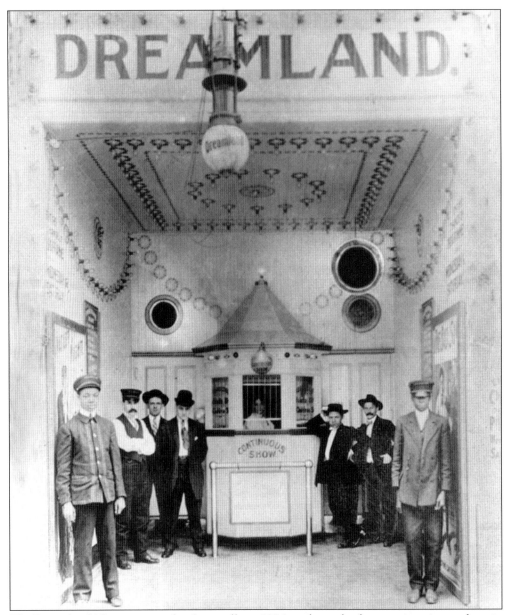

The Dreamland Theater opened in Louisville in 1904, and was the first moving picture show in the city. The 100-seat theater showed 15-minute nickelodeon films. It was one of the first movie theaters in the country.

Three

PLAY IN LOUISVILLE

Sports and amusement have a long tradition in Louisville. Recreation has been focused on the river, and many steamboats and smaller craft offered cruises. Several amusement parks sprang up along the river, including White City, Fontaine Ferry, and Rose Island, in Clark County, Indiana. Additionally, the city built a system of parks and parkways from the 1890s to the 1940s, including Iroquois, Tyler, Shawnee, Chickasaw, and Cherokee Parks.

Horse racing dates to early settlement, with the first race believed to have been held on Market Street in 1783. The first race course was built on Shippingport Island in 1805 and called Elm Tree Garden. Other race courses were the Hope Distillery Course and Oakland Race Course. The Louisville Jockey Club was formed in 1874 on land owned by the Churchill family. The first race at the club was held on May 17, 1875 and called the Kentucky Derby. A clubhouse with "twin spires" was built in 1882, and the course was renamed Churchill Downs by club president Matt Winn.

Baseball was played by professional and by amateur leagues as early as 1858. The first meetings to organize the National League were held at the Louisville Hotel on Main Street in 1875. Louisville was the site of the first National League game ever played on April 25, 1876, when the Louisville Grays were shut out in a game against the Chicago White Stockings—now the Chicago Cubs.

Boxing has been an important sport to the city, and Louisville has been home to heavyweight champions Marvin Hart, Muhammad Ali, Jimmy Ellis, and Greg Page. Hart won the championship in 1905, and Ali was a boxing phenomenon during the 1960s and 1970s. Ellis held the heavyweight title in 1968–1970, and Page won the World Boxing Association title in 1984.

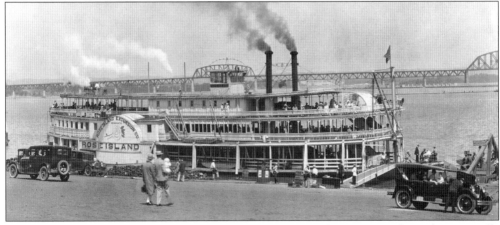

The steamboat Rose Island was an excursion boat that took passengers from the Louisville wharf to Rose Island in Clark County, Indiana. This photograph from 1927 shows the boat being loaded with passengers for a trip to the popular amusement park.

89

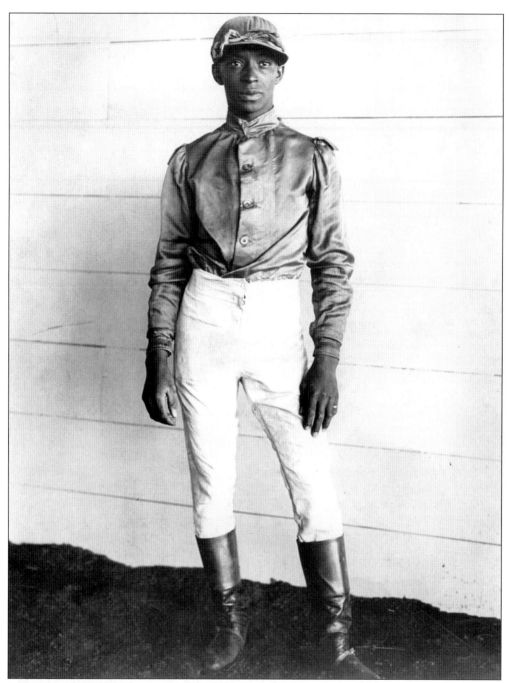

Jockey James Winkfield won the Kentucky Derby on "His Eminence" in 1901 and "Alan-a-Dale" in 1902. The jockey had come in on the third-place horse in the 1900 Derby. Winkfield was hired by Czar Nicholas II to ride his thoroughbreds, and he was charged with transporting 200 of the czar's horses to France in 1917 after the confiscation of the royal estate. He went on to become a successful trainer in France. This photograph shows Winkfield standing in a position of readiness and relaxation. The jockeys in the Kentucky Derby were traditionally African American from its beginning in 1875 to the 1900s.

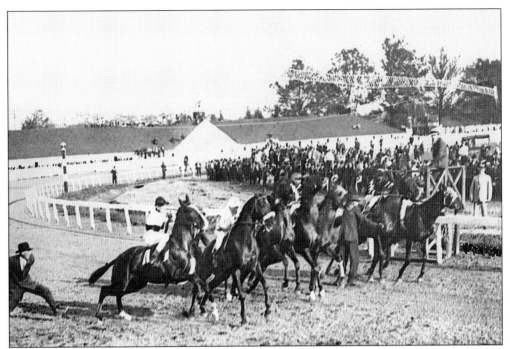

The crack of the starter's whip began the Kentucky Derby in 1914. The horses were not loaded into gates, but lined up on the track, and the starter, at lower left, stood behind them and cracked a leather whip. The winner of this race was "Old Rosebud," who won in two minutes, three and three-fifths seconds.

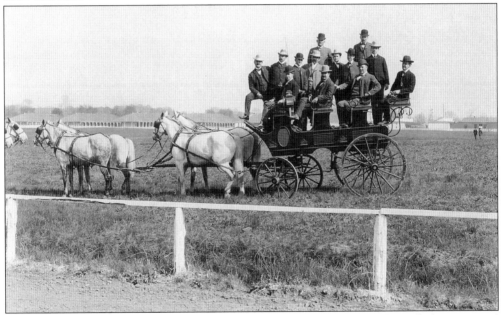

The governor of Kentucky traditionally attends the Kentucky Derby and is called on to award the garland of roses and trophy to the winning horse, jockey, and owners. This photo in 1901 shows Governor Beckham on a wagon in the infield with an unknown party. John Crepps Wickliffe Beckham was governor of Kentucky from 1900 to 1907.

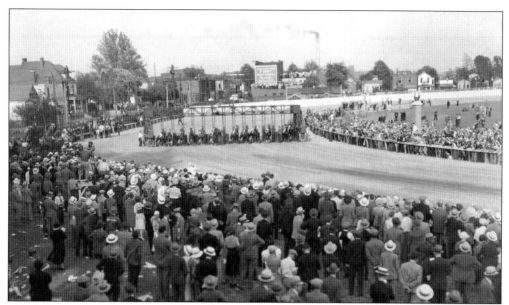

The first use of the starting stall-gate mechanism was at the 1930 Kentucky Derby. This photo shows the start of the 1931 race with the horses in the gate. The fall meet at Churchill Downs was cancelled in 1931 because of the financial impact of the Great Depression.

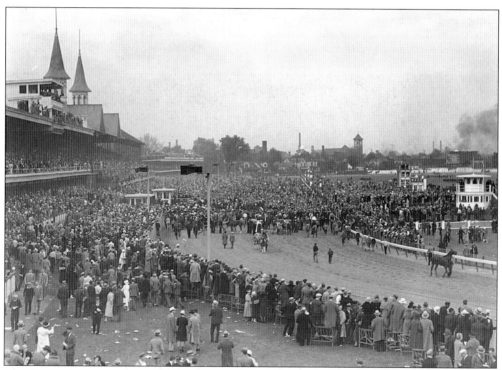

The Kentucky Derby grew in popularity under the leadership of club president Matt Winn, named general manager in 1903. Winn successfully reinstituted parimutuel betting after a 30-year absence from the track in response to a city ban on gambling. This photo shows the crowd at the 1933 Kentucky Derby and attendees walking onto the track after the race.

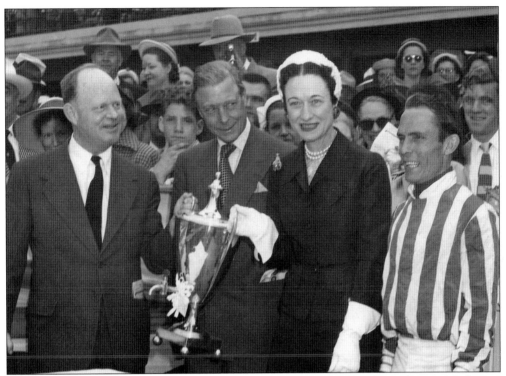

The winner of the 1951 Kentucky Derby was "Count Turf," ridden by jockey C. McCreary. The presentation of trophies that year was made by royal celebrities the Duke and Duchess of Windsor.

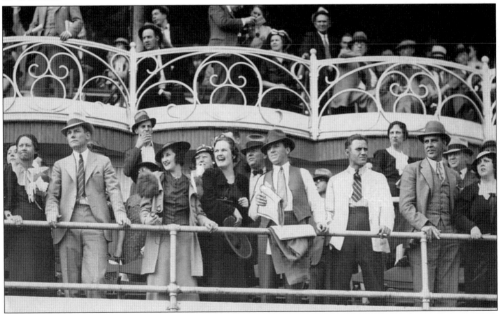

The Kentucky Derby is one of nine races run at Churchill Downs on the first Saturday in May, although the entire event is called Derby Day across the city. Horse races create winners and losers, as indicated by the faces of these folks in 1934. "Cavalcade" was the winner here.

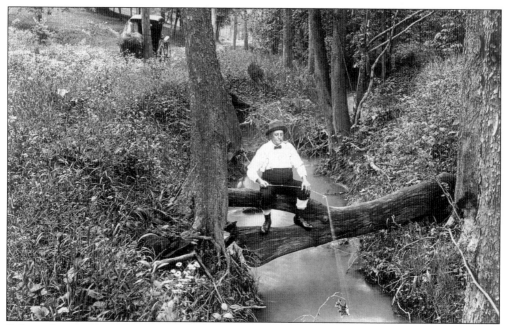

Solitary leisure activities were sought by Louisvillians. Fishing in the Ohio River and Beargrass Creek were common pastimes. In this photograph, H.J. Smith fishes in Beargrass Creek in Cherokee Park in 1910. Smith had stopped to fish on his way home from work. His horse Molly waits at the roadside while Mrs. Smith and dinner wait at home.

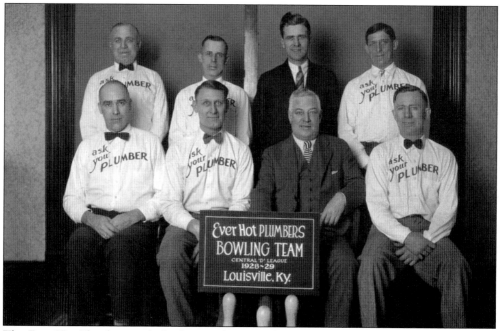

The Ever Hot Plumbers took the league championship in 1929. Bowling leagues for men and women have been popular in Louisville since the 1920s.

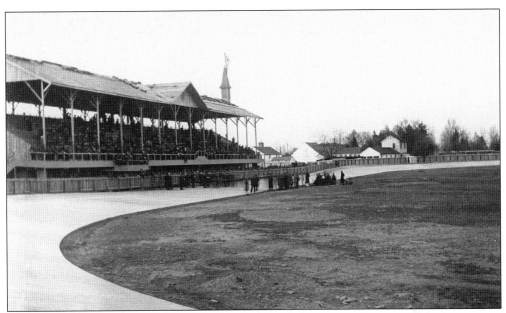

A velodrome was located at Fontaine Ferry Park. The bicycle-racing track had a frame grandstand that resembled the early grandstands at Churchill Downs. This photo from 1896 shows the stands filled with people and a race ready to begin.

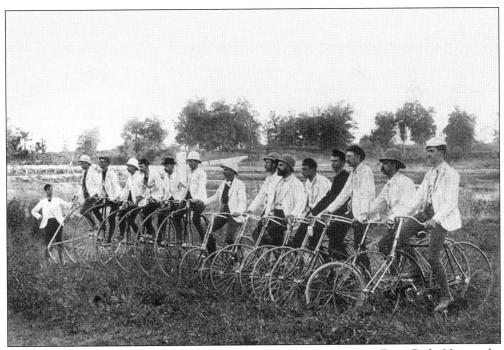

These cyclists from 1890 are posing with their bicycles at Fontaine Ferry Park. Notice the different designs and wheel sizes of the bicycles, and the white jacket and tie on most riders.

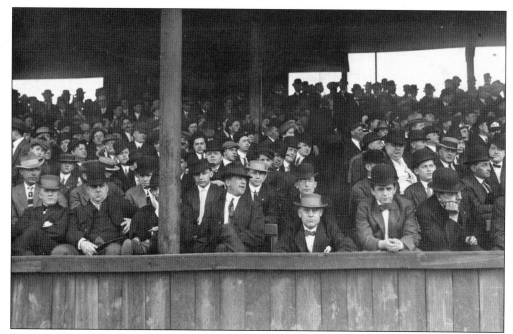

Opening day of the 1912 baseball season at Eclipse Park was a big day in Louisville, with a sell-out crowd in the stands. Eclipse Park was the home of minor league team the Louisville Colonels until 1922. The park was destroyed by a fire in 1922, and baseball was moved to a new location—Parkway Field at Brook and Eastern Parkway.

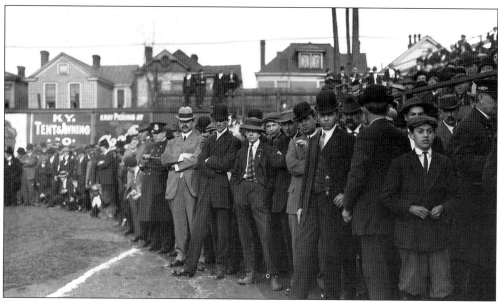

These well-dressed fans are part of the overflow crowd for the Louisville baseball club's home opener in 1912 at Eclipse Park, located at Seventh and Kentucky Streets. The team's traditional opening day rival was the Toledo Mud Hens.

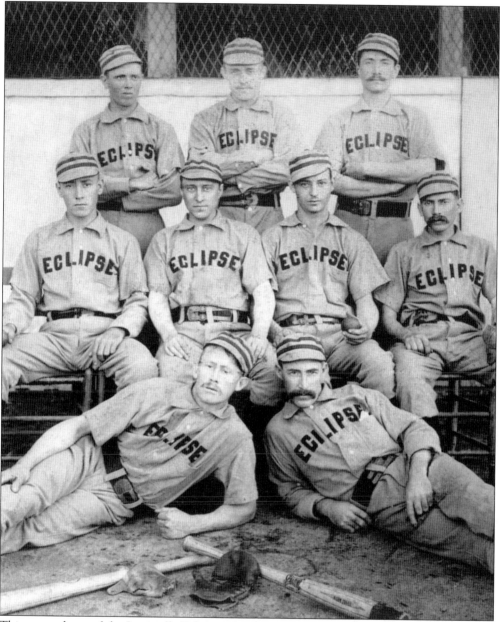

This team photo of the Louisville Eclipse was taken in 1880. The team played at the original Eclipse Park at Twenty-eighth and Elliot Streets. This team became a charter member of the American Association in 1892, a major league established to rival the National League.

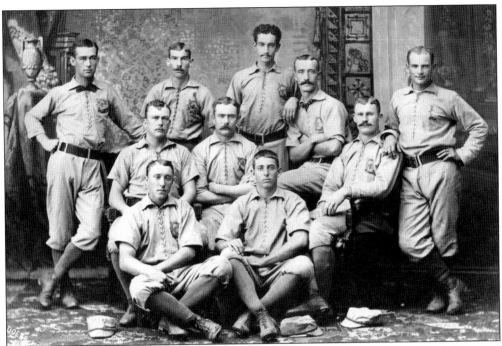

The Louisville Eclipse club poses for the photographer in 1882, the year they joined the major league American Association. Second from the left in the back row is Pete Browning, for whom the first Louisville Slugger bat was made. Browning played major league ball from 1882 to 1894 with a lifetime batting average of .341.

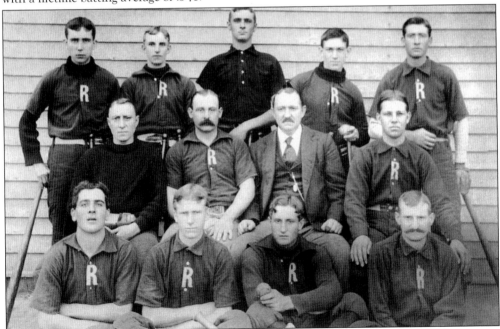

One of the many semi-pro teams that played in Louisville was this one sponsored by sporting goods magnate J.W. Reccius, who is also seen in the top photo (first row, left) as a center fielder for the Eclipse team.

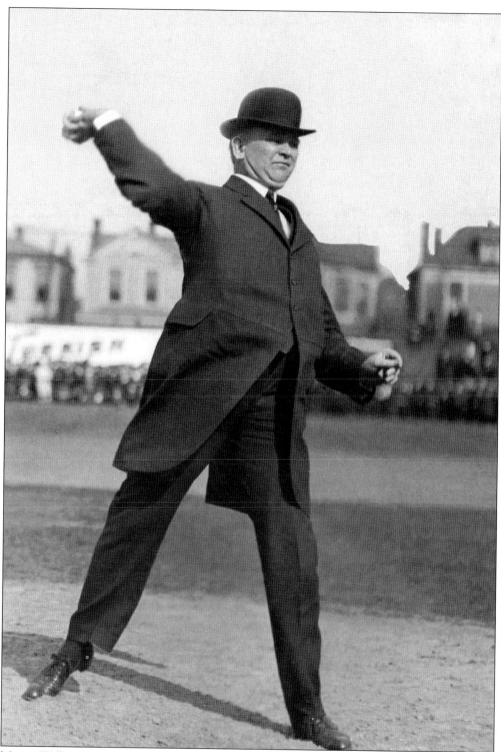

Mayor William O. Head throws out the first pitch in the 1912 opener at Eclipse Park at Seventh and Kentucky.

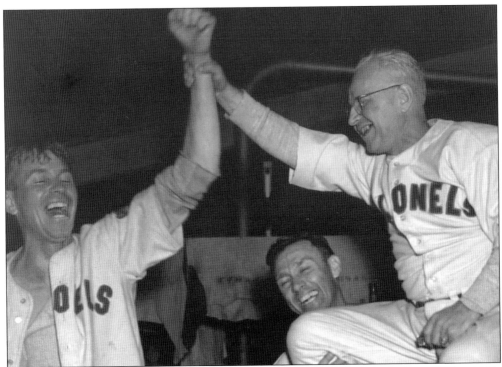

The Louisville Colonels were an American Association Minor League team from 1902 to 1962. From 1938 to 1962 the Colonels were the farm team for the Boston Red Sox. Here, they celebrate their 1946 pennant win. The team won the Little World Series five times.

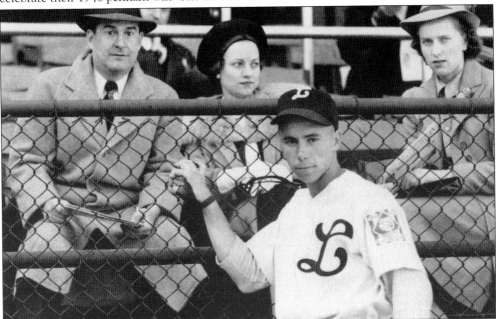

This photo records Pee Wee Reese's debut with the Louisville Colonels in 1939 at Parkway Field. The women are not identified, but the man is longtime Manual High baseball coach Ralph Kimmel. Reese went on to become a Hall of Fame shortstop with the Brooklyn Dodgers.

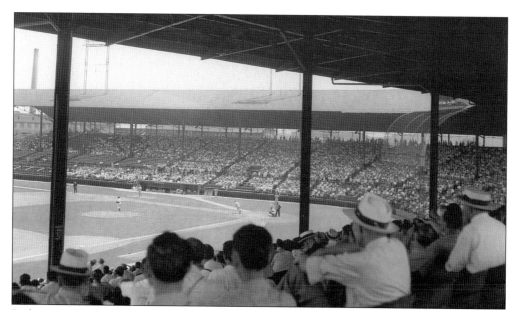

Parkway Field was the home of the Louisville Colonels from 1923 through 1955. Located on the south side of Eastern Parkway, east of Third Street, it replaced Eclipse Park, which burned in 1922. This photograph from around 1950 shows the stands full.

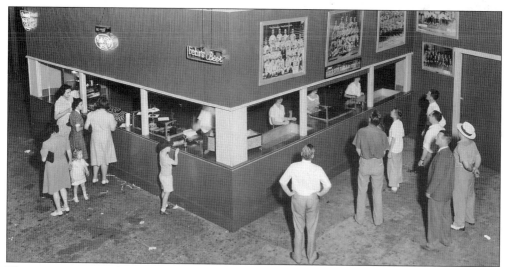

The concession stand at Parkway Field featured locally brewed Oertel's, Falls City, and Fehr's beer, along with historic photographs of earlier baseball teams. The American Association was called the "Beer and Whiskey League" because beer was sold at the games.

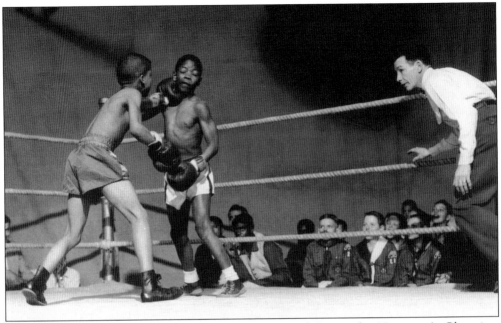

Young Golden Gloves boxers coached by Joe Martin fight on the *Tomorrow's Champions* television show. Martin was Muhammad Ali's first coach.

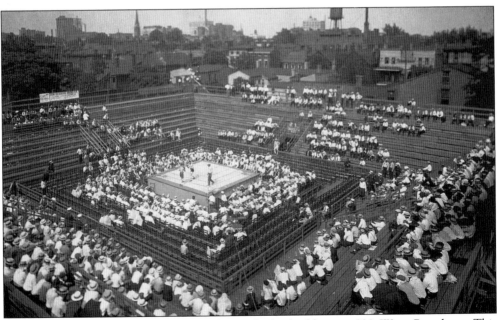

The Broadway Athletic Club was on the roof of a building at 823 West Broadway. This photograph shows the outdoor exposition arena for boxing matches in 1921.

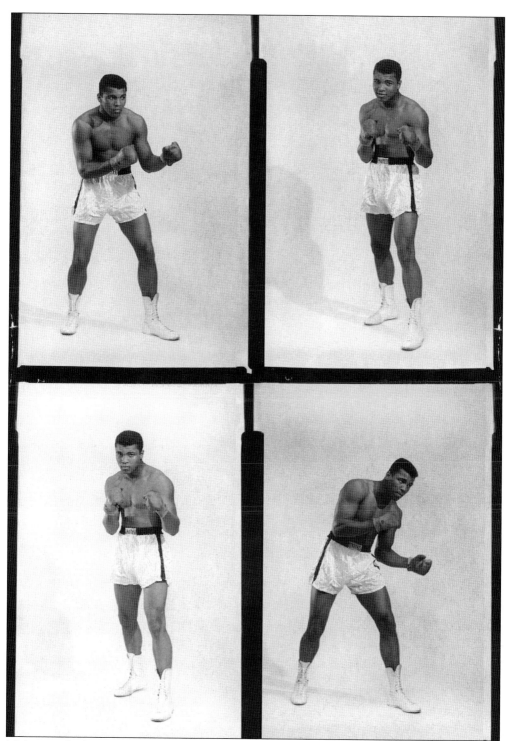

Muhammad Ali posed for Louisville photographer Lin Caufield in the early 1960s. Ali was born in Louisville and trained at a local gym. According to his trainer, Ali took up boxing to learn how to fight after his bicycle was stolen.

The Amphitheater Auditorium was located on the southwest corner of Fourth and Hill. The frame building held 3,000 seats and featured dramas, operas, musicals, lectures, and boxing. An outdoor area, which included an artificial lake, hosted bicycle races and elaborate fireworks displays.

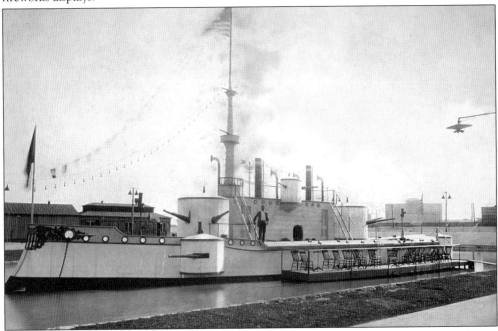

A production of *The Pirates of Penzance* at the Auditorium led to the construction of the set pictured in this photograph. The theater operated from 1889 to 1904, and was the site of John Philip Sousa's final band concert of his career.

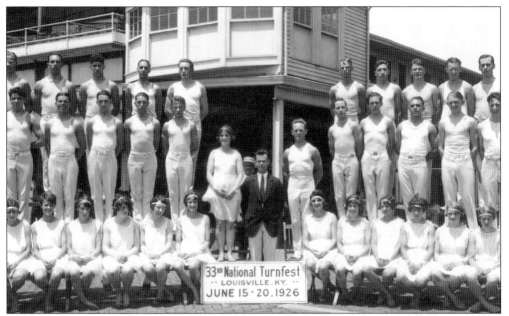

The Turners are a gymnastics and fitness society brought to Louisville by German immigrants. The group opened the first gym in the city in 1850 in a shed between Third and Fourth on Market. The group purchased a site on the Ohio River in 1911 that they named Turner Park.

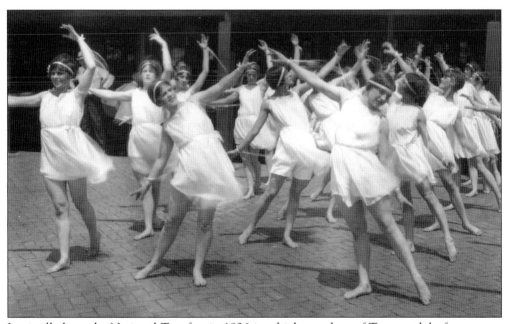

Louisville hosted a National Turnfest in 1926 in which members of Turners clubs from across the country competed against one another.

Tyler Park was designed by the landscape firm of Olmsted Brothers as a site of both active and passive leisure. Tennis courts, wading pools, and curved walkways were incorporated into the plan. A remarkable feature of the park is a stone bridge that carries Baxter Avenue traffic over the park and creates an access tunnel so park visitors do not have to cross a busy street.

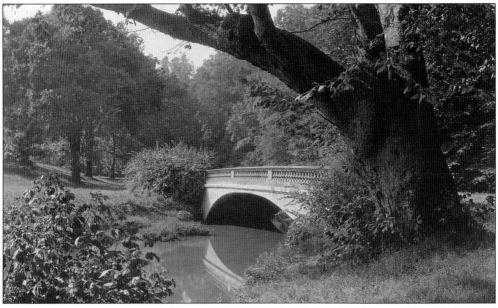

Cherokee Park's main natural feature is Beargrass Creek. Frederick Law Olmsted designed the park to take advantage of the meandering nature of the creek and designed roads to cross the creek on beautifully detailed bridges. This bridge, known as Bridge Number 5, was photographed in 1926.

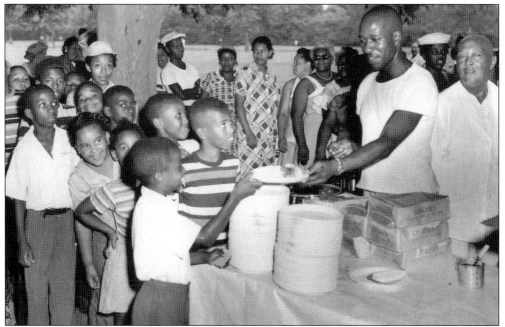

Chickasaw Park was designed by the Olmsted Brothers and built by the city in 1922 to provide a park for African-American children in Louisville. The public parks were segregated as were most of the private amusement opportunities in the city. This photograph shows a company picnic for African-American employees of the Dearing Printing Company as they enjoy sack races and a barbequed lunch at Chickasaw. The same day found the company's white employees and their families enjoying the rides and a lunch at segregated Fontaine Ferry Park.

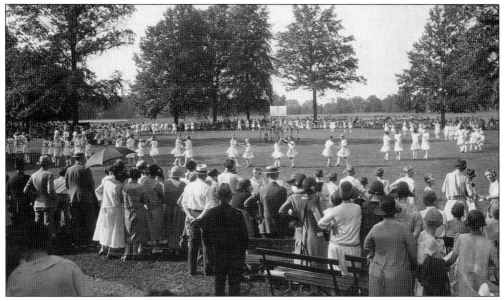

Shawnee Park was designed by Frederick Law Olmsted with a lily pond and breathtaking vistas of the Ohio River. The park was the site of band concerts and performances, and people would ride the trolley west on Broadway to the park. This photograph shows a school pageant held at the park in the summer of 1925.

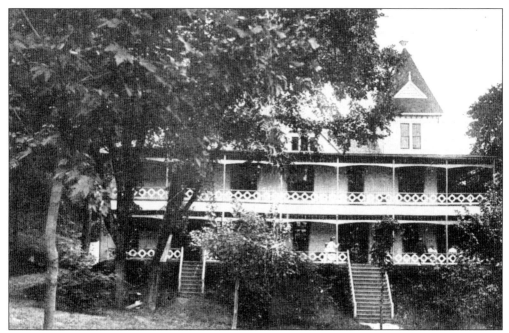

This hotel at Rose Island was located in Clark County, Indiana, across the Ohio River from Louisville. The park featured cottages, picnicking, swimming, a small zoo, and a dance pavilion. Steamboats carried people to the park from landings at the wharf and at Fontaine Ferry Park.

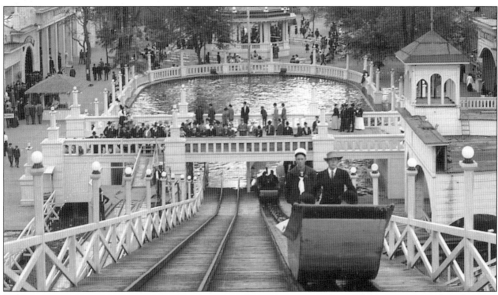

White City was an amusement park opened in 1907 on the Ohio River at the foot of Greenwood Avenue. The site was renamed Riverview Park in 1911, but closed in 1913. The area had become residential by 1922.

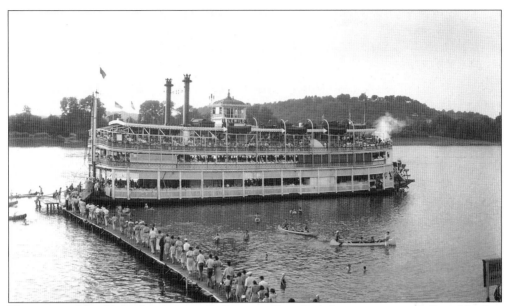

The steamer *Idlewilde* loads passengers at Fontaine Ferry Park for an excursion to Rose Island in 1934. The *Idlewilde* was renamed the *Avalon* in 1948; it was purchased by Jefferson County in 1963 and renamed the *Belle of Louisville*.

Picnickers at Rose Island in 1926 beat the heat under a grove of mature trees while waiting for the steamboat that will take them back to the city.

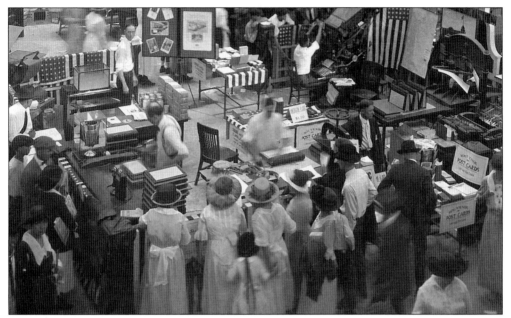

The exhibits area at the 1921 Kentucky State Fair featured this full-scale printing and bookbinding operation with linotype machine and operator. The fairgrounds were then located at Cecil and Twenty-eighth Streets.

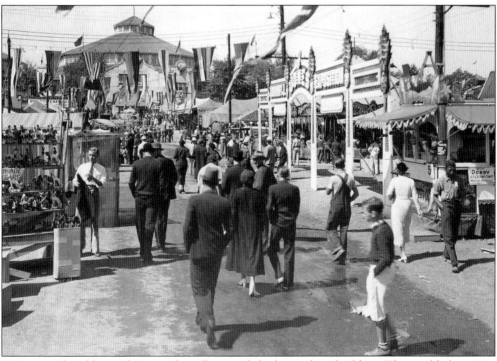

Visitors to the old state fairgrounds walk toward the horse show building. The world champion horse show was held at the site each year. This photograph was taken from the midway in 1938.

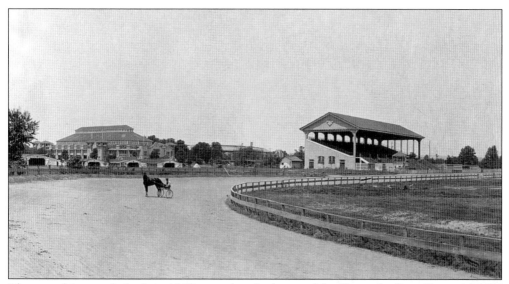

The state fairgrounds, built in 1908, served as the home of the Kentucky State Fair until 1956 when new fairgrounds were built on a site bordered by Crittenden Drive, Preston Street, and Phillips Lane. The Watterson Expressway was completed in 1958, providing highway access to the site. This photograph from 1921 shows the trotting track at the old fairgrounds.

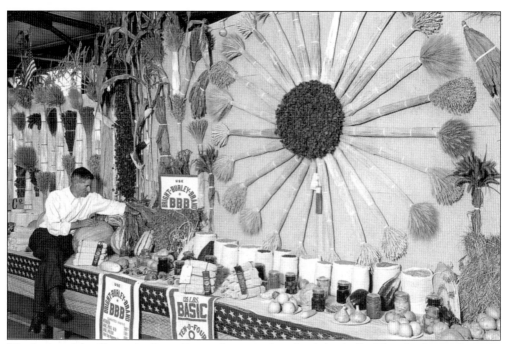

The heart of the Kentucky State Fair is the agricultural exhibit halls. This display at the 1939 fair showcases grains and produce. Following fairs throughout the summer in all 120 Kentucky counties, the state fair serves as the highlight of the fair season.

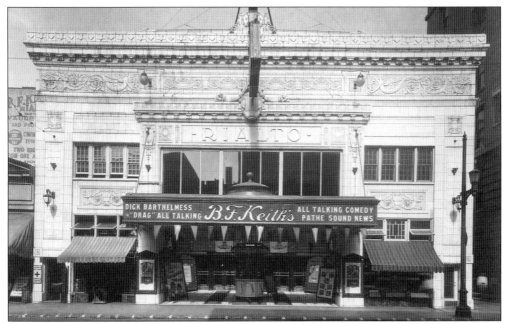

The Rialto was designed by Louisville architects Joseph and Joseph. The building was modeled on the Capitol movie theater in New York City, fitted with a Rookwood tile facade, and could seat 3,500 patrons.

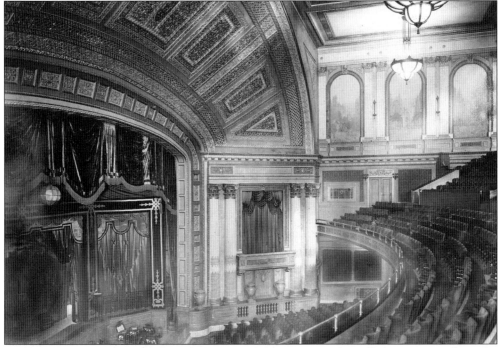

Movie palaces were located throughout central downtown and smaller versions such as the Aristo, the Crescent, and the Oak were built in neighborhoods. Fourth Street theaters included the Loews, the Ohio, the Kentucky, and the Mary Anderson. The Rialto, seen here in an interior view, was demolished in 1969 to make way for a parking lot.

The Rialto Theater at 616 South Fourth Street was designed in the tradition of movie "palaces." The interior, shown here, featured a marble grand staircase. The interiors of early movie theaters often had a dreamlike quality and featured air-conditioning and other amenities.

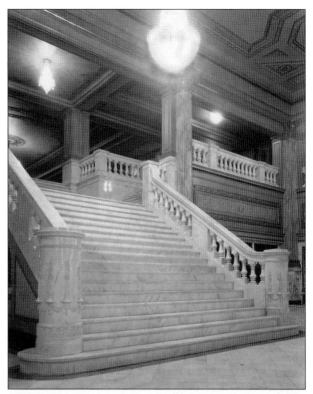

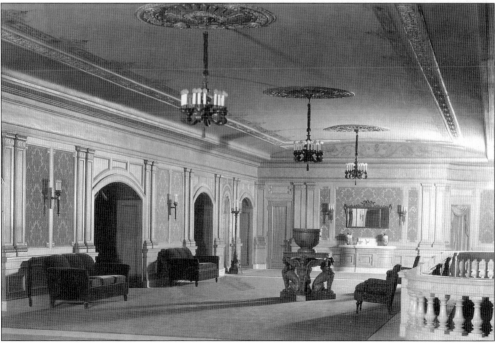

The Promenade at the Rialto was the second-floor entrance to the balcony seating. The theater, which opened in 1921, was decorated with exotic fabrics and furnishings, very different from the homes where the movie patrons lived.

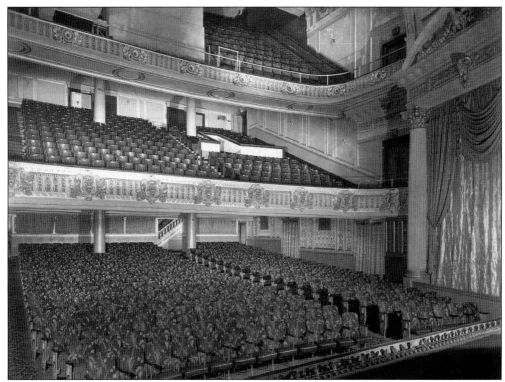

The Mary Anderson Theater, which had double balconies, opened as a theater for stage plays in 1907. It later hosted vaudeville acts and Louisville's first "talking" motion picture in 1909 when actors stationed behind the screen synchronized their spoken parts with the actors on the screen. The theater showed movies exclusively after 1913. It closed in 1972.

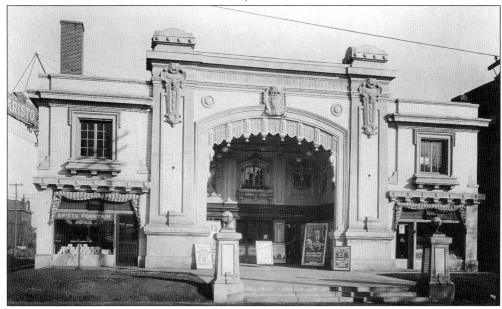

The Aristo Theater, located at 1603 South Second Street, was another of the Louisville theaters designed by architects Joseph and Joseph.

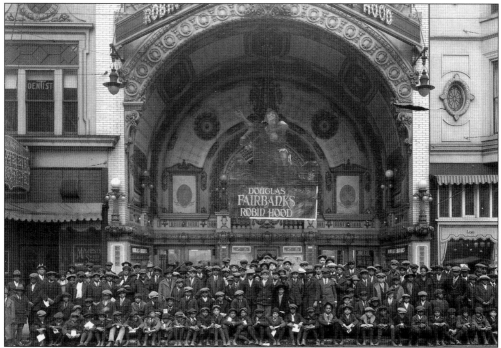

The Majestic Theater was built in 1912 as a movie theater outfitted with 1,000 seats. The ornate entrance was illuminated by hundreds of electric lights. This photograph shows a group of boys in front of the theater; they may be newspaper carriers being treated to a show. The building, at 544 South Fourth Street, was torn down to make way for an office building in 1928.

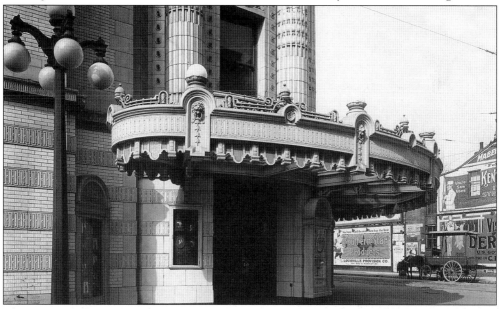

The National Theater was built on the southwest corner of Walnut (Muhammad Ali) at Fifth Street. The National was designed with an ornate tile facade and dramatic marquis entrance. The theater showed vaudeville acts and movies but was torn down in 1952 to make a parking lot for the Kentucky Hotel.

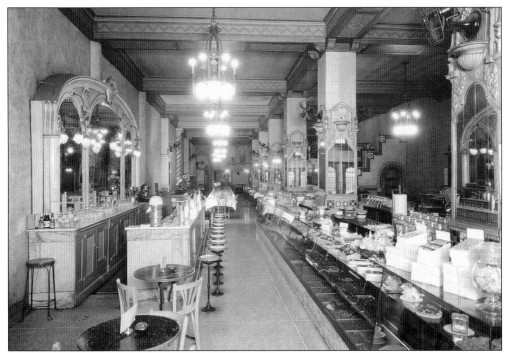

Restaurants in Louisville had early beginnings in taverns and saloons. Louisville's position at the Falls created a necessity for hotels and restaurants for the many people traveling through the area, and restaurants became places for social interaction and good food. Jennie Benedict trained as a chef with Fannie Farmer and returned to Louisville to open a catering business. She opened the restaurant pictured here in 1902.

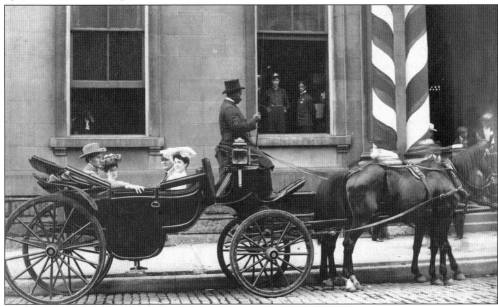

The restaurant in the Galt House was viewed as the last word in dining to generations of Louisvillians and set the standard for later hotels. Presidents from Ulysses S. Grant to Theodore Roosevelt stayed at the Galt House.

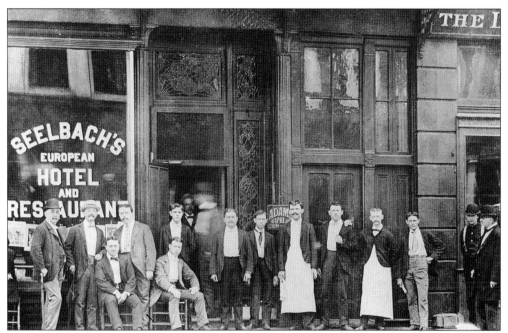

The original Seelbach Hotel was opened in 1880 on the southwest corner of Sixth and Main by German immigrant brothers Louis and Otto Seelbach. Their new hotel, the present Seelbach, opened at Fourth and Walnut in 1905.

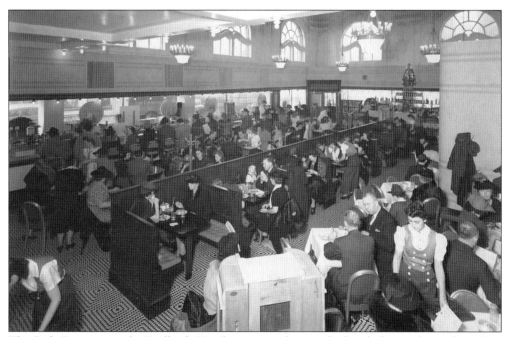

The Soda Fountain at the Seelbach Hotel was a popular spot for lunch during the work week or during a day of shopping on Fourth Street. This photograph from 1941 shows a full house.

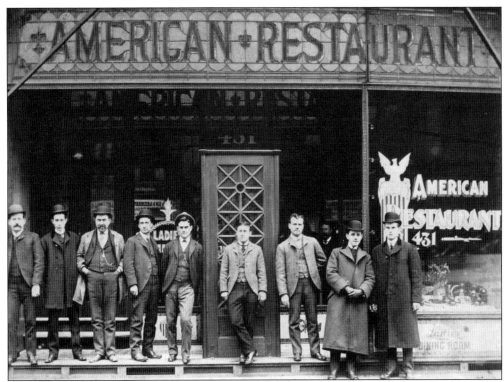

The American Restaurant, operated by the Mivalez family, was at 431 West Market Street. This photograph is from about 1900.

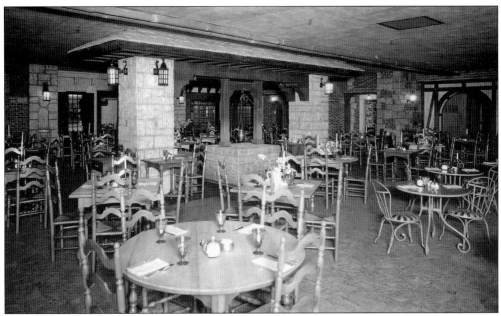

Many office buildings downtown were complete with restaurants. The French Village was located in the basement of the Heyburn Building at Fourth and Broadway.

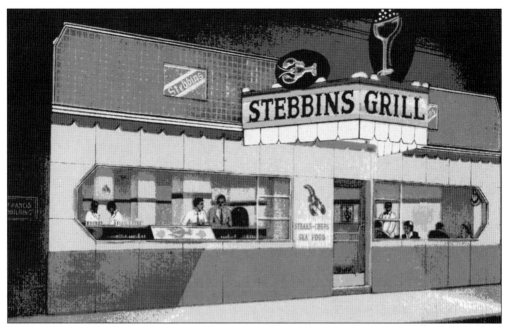

Stebbins Grill at 412 West Chestnut Street served live lobster and soft-shell crab, scallops, and other fish that was delivered daily. The menu also featured choice cuts of beef and a selection of fine wines and spirits.

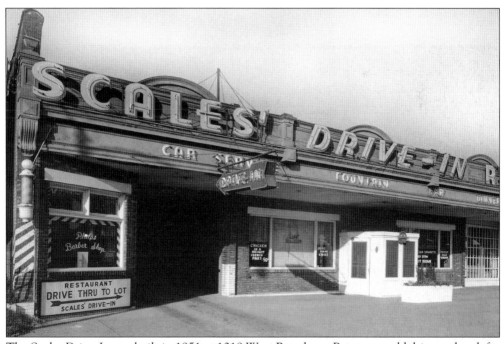

The Scales Drive-In was built in 1951 at 1019 West Broadway. Patrons would drive and park for curb-service dining. This style of restaurant became popular across the city, including Dizzy Whiz on St. Catherine Street and A&W Root Beer on Dixie Highway.

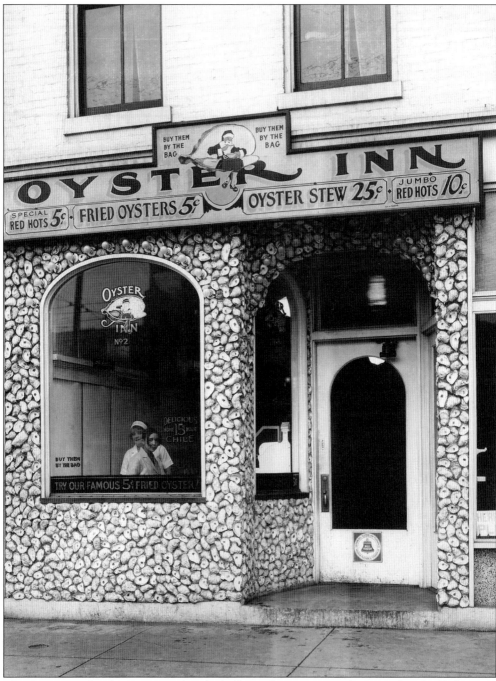

The Oyster Inn facade was covered with shells to advertise its product. Fried and rolled oysters were featured on menus across the city.

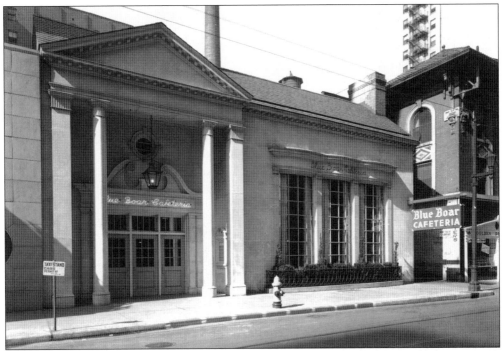

The Blue Boar Cafeteria was a chain restaurant that opened in Louisville in 1931 on Fourth Street. The restaurant featured two lines and seating in the basement and on balconies. The restaurant went on to open six more locations over the next decades but closed in the 1990s due to increased competition.

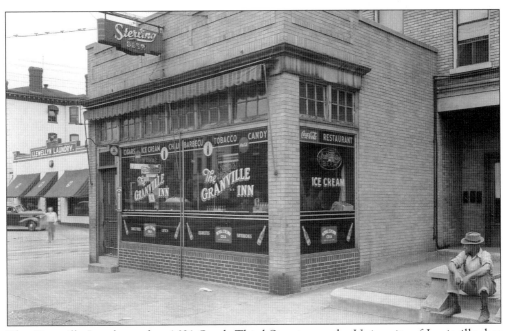

The Granville Inn, located at 1601 South Third Street near the University of Louisville, has been popular with generations of students and faculty.

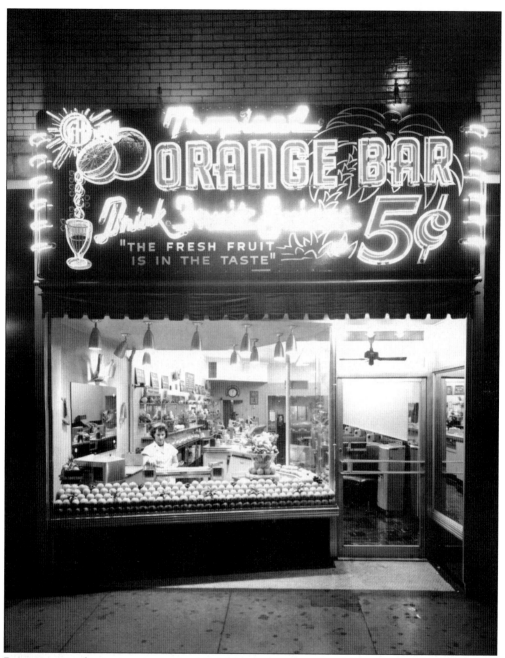

Restaurants with counter service and quickly prepared snacks and meals were located in the shopping district on Fourth Street. The Orange Bar prepared freshly squeezed orange juice while you waited. The large storefront window enticed customers with a full view of the inside of the restaurant and fresh fruit in the window.

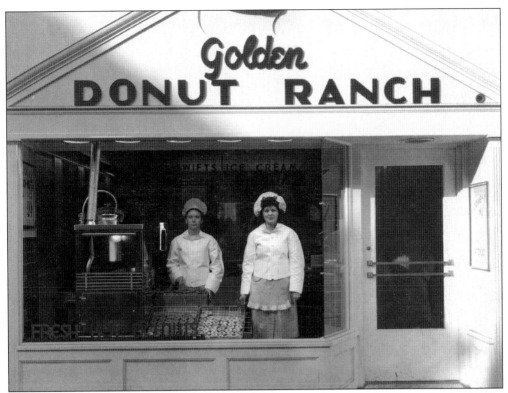

Donuts were a craze following the start up of chains such as Krispy Kreme in the 1930s. The Golden Donut Ranch, pictured above, had stores on Fourth Street and on Walnut Street in the 1940s.

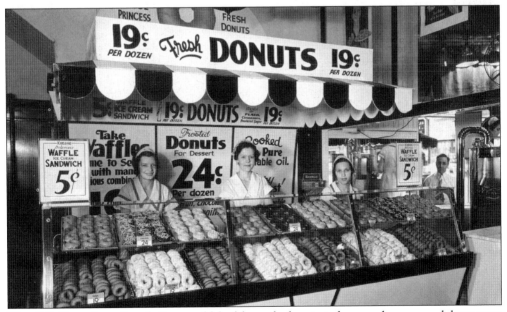

This S.S. Kresge's on Fourth Street sold freshly made donuts to hungry shoppers and downtown office workers.

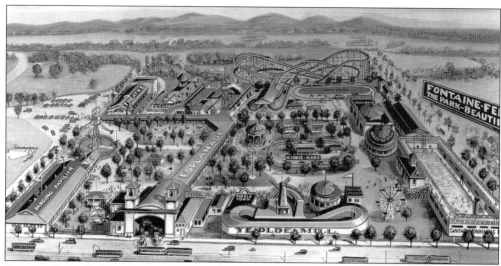

Fontaine Ferry Park was built in 1905 and stayed in operation until 1969. The park had rides, a dance hall, a roller rink, and a wooden rollercoaster. Located on South Western Parkway on the Ohio River, it was the longest-operating amusement park in the city.

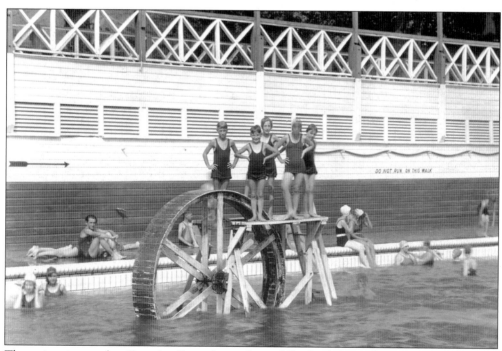

The swimming pool at Fontaine Ferry featured a paddlewheel diving board. This photograph from 1929 shows children in bathing costumes taking advantage of the pool to beat the heat.

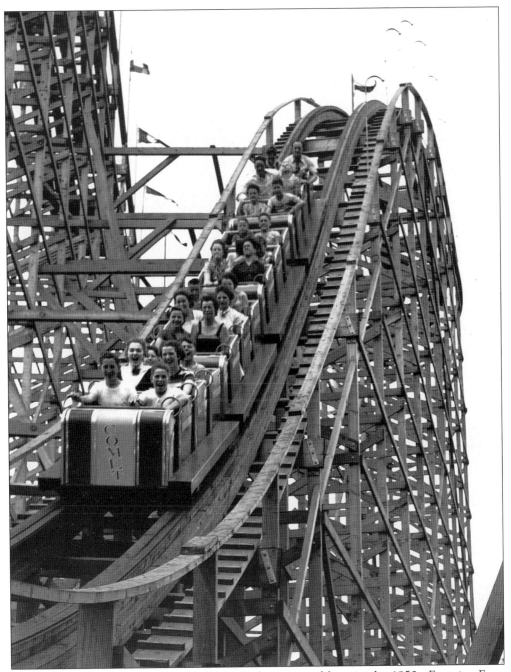

The Comet rollercoaster at Fontaine Ferry Park is pictured here in the 1950s. Fontaine Ferry Park ownership refused to integrate the park following local and federal changes to segregation laws. The park was racially integrated in 1964 but was heavily damaged by race riots in Louisville in 1969 following the assassination of Rev. Dr. Martin Luther King Jr.

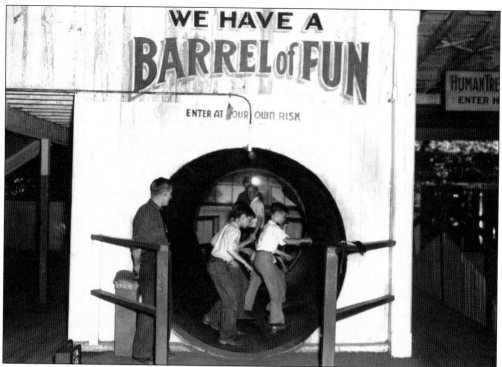

Fontaine Ferry catered to families, couples, and groups for outings on the Ohio River. In the style of amusement parks developed around the country at the same time, the park was designed to delight visitors with food and fun. The buildings were ornately decorated and the rides were designed to thrill visitors. The Barrel of Fun was a large, slowly spinning tube that turned visitors upside down. These boys are trying to stay upright while the barrel turns.

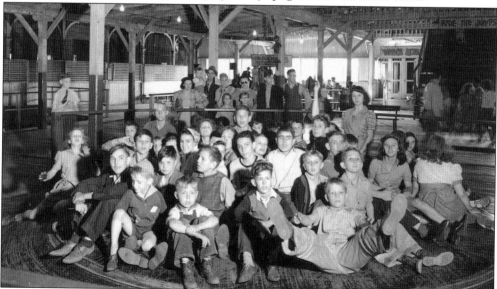

The Wheel of Joy required riders to sit on a huge disc that would be spun very quickly. Girls had to be careful that the wind did not blow their dresses up. These children are waiting for the spinning to begin.

Television became a medium for entertainment in 1948 when WAVE television opened the first station in Louisville. The station presented the first broadcast of the Kentucky Derby in 1949. WHAS went on the air in 1950, and broadcast such programs as T-Bar-V Ranch, pictured above. T-Bar-V Ranch featured radio personalities "Cactus" Tom Brooks, on the left, and Randy Atcher on a live show with an audience of children celebrating their birthdays. The theme song, which encouraged good manners and behavior, is part of Louisville lore. WLKY went on the air in 1961, and WDRB began as an independent station in 1971.

ABOUT THE IMAGES

The images for the book were chosen from the collections of the University of Louisville Photographic Archives. Considered to be one of the best university collections in the country, the Archives houses 1.5 million images donated to and purchased by the University. The collections of professional photographic studios Caufield and Shook (1903–1972), Royal Studio (1903–1972), Lin Caufield (established 1954), and of collector R.G. Potter are supplemented in the book by stereoscope views and postcard images.

The Photographic Archives is located in the Special Collections Department of the Ekstrom Library on the Belknap Campus of the University of Louisville. Those interested in the visual history of the community are encouraged to take advantage of the vastness of the collection. The URL address for the Archives website is as follows:
http://www.louisville.edu/library/ekstrom/special/pa_info.html.

SELECTED SOURCES

Harrison, Lowell H. and James C. Klotter. *A New History of Kentucky*. Lexington, Kentucky: The University Press of Kentucky, 1997.

Kleber, John, ed. *Encyclopedia of Louisville*. Lexington, Kentucky: The University Press of Kentucky, 2000.

Kleber, John. ed. *Kentucky Encyclopedia*. Lexington, Kentucky: The University Press of Kentucky, 1992.

Neary, Donna M. *Historic Jefferson County*. Louisville, Kentucky: Jefferson County Fiscal Court, 2000.

Yater, George. *Two Hundred Years at the Falls of the Ohio: A History of Louisville and Jefferson County*. Louisville: The Filson Club, 1987.

Ulack, Richard, ed. *Atlas of Kentucky*. Lexington: The University Press of Kentucky, 1998.